Plants, flowers, gardens, insects and birds are a rich source of inspiration for artists and designers of all kinds. This beautiful guide demonstrates how to get the most out of your surroundings to create original and unique textiles.

Beginning with Drawing from Nature, the book demonstrates how to use sketchbooks and create mood boards to explore your local environment and landscape, building up to making small pieces such as folding books based on observational drawing and stitch. Moving on to Planting in Cloth, the author shows how to use plants and flowers in your work, from using stencilled flower motifs as embellishment to printing with plants onto fabric and making simple relief prints. Finally, Taking Flight demonstrates how to move into three-dimensions, installations and sculptural work with birds and insects made from cloth.

This wonderful collection is bursting with ideas for working with green spaces, demonstrating how to connect with your environment by using local resources such as plant dyes or found objects. Featuring step-by-step projects as well as work from contemporary artists, makers and collaborative groups throughout, this practical and beautiful guide shows how practitioners of all kinds can draw from the natural world for making and inspiration.

Textile Nature

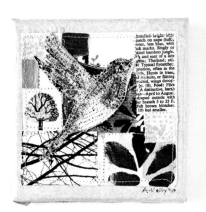

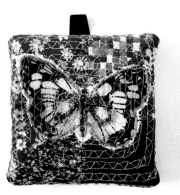

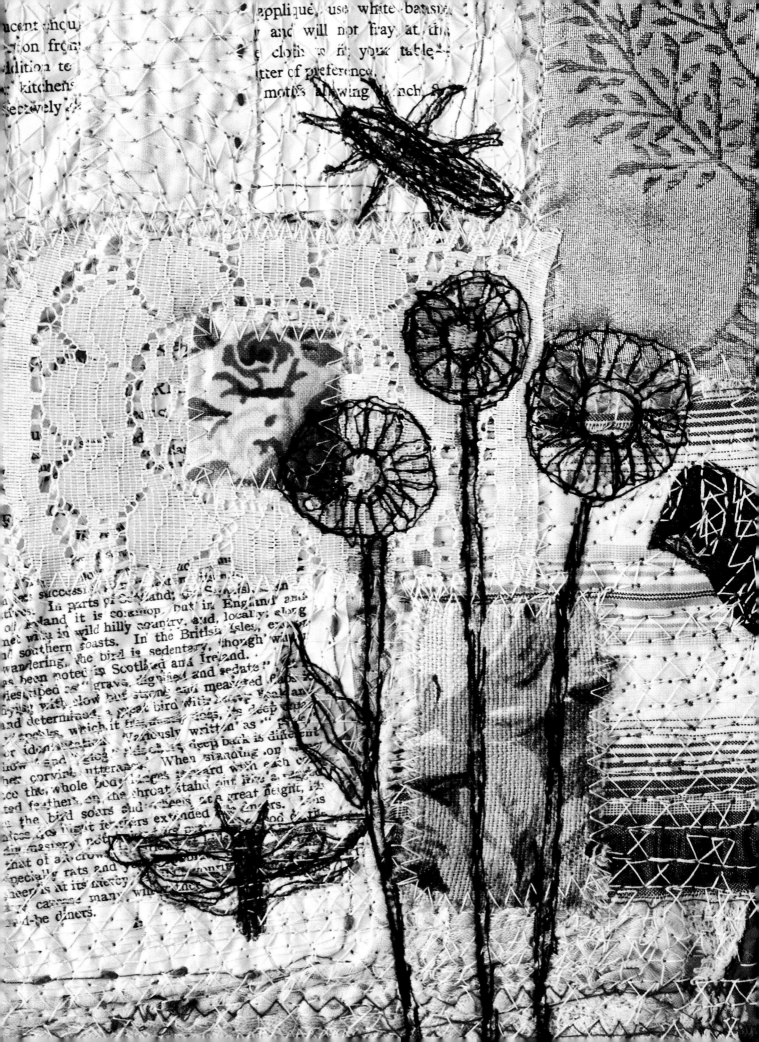

Textile Nature

Textile Techniques and
Inspiration from the
Natural World

Anne Kelly

BATSFORD

Acknowledgements

I would like to thank the artists and students named in the text for their contributions (see featured artists on page 122 for their details) and the institutions and organizations mentioned in the book for sharing their collections and images. Thank you also to Rachel Whiting, photographer, to Tina Persaud and Kristy Richardson at Batsford for their support of this project, and to family and friends for their unwavering good humour.

First published in the United Kingdom in 2016 by
Batsford
1 Gower Street
London WC1E 6HD

An imprint of Pavilion Books Company Ltd

ISBN: 9781849943437

A CIP catalogue record for this book is available from the British Library.

20 19 18 17 16
10 9 8 7 6 5 4 3 2 1

Reproduction by Mission Productions, Hong Kong
Printed in Singapore

This book can be ordered direct from the publisher at the website: www.pavilionbooks.com, or try your local bookshop.

Distributed in the United States and Canada by
Sterling Publishing Co., Inc.
1166 Avenue of the Americas, 17th Floor,
New York, NY 10036

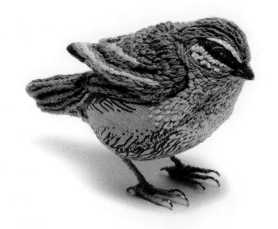

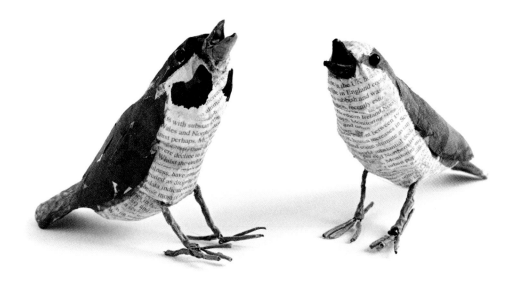

Contents

Introduction

'There are three principal means of acquiring knowledge ... observation of nature, reflection and experimentation. Observation collects facts; reflection combines them and experimentation verifies the result of that combination.'

Denis Diderot, French philosopher

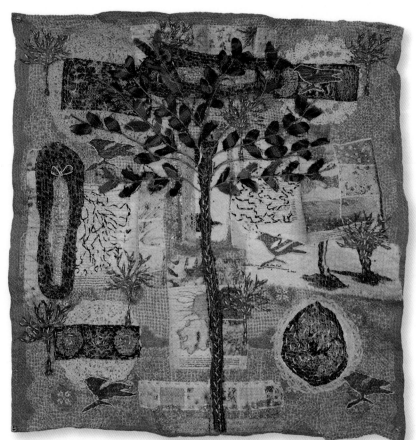

Bay Tree and Shoe
by Anne Kelly.

Artists, designers and makers have always been influenced by nature, and textile artists even more so. An early series of my textile work was based on drawings of plants from the garden and as my pieces have grown in size and complexity, I've kept and valued a connection with the natural world. Through my teaching and travels with my work, I've observed that practitioners of all ages and abilities share a huge common love of nature and textiles, which has inspired me to write this book.

The journey will take you from its starting points through to making and exhibiting, looking at inspirational examples from around the world, and help you to 'grow your own' work and connect with green spaces. I believe that observing nature can provide you with a wealth of information and resources for making unique and meaningful work.

Chapter 1: Drawing from Nature will bring you closer to the natural world, and will show you how to organise your resources to generate creativity and enhance your studio practice. Looking at sketchbooks, folding books, a 'nature table' and recording information in different formats will enable you to make work using a variety of art and textile techniques.

Chapter 2: Planting in Cloth. Any student of textile design will recognise the staying power of the plant and floral image. Whether looking at single or many species, pattern, leaf or bud,

Inside the images:

artichokes

De morgan tile

Print leaf surfaces

dye from leaf

plants provide endless possibilities for print, stitch, dye or construction. Simplifying your designs and making a printing block can enable you to use one design in a variety of ways.

In **Chapter 3: Taking Flight**, bird and insect motifs, and how to make and use them in your work, are the focus. These subjects are increasingly popular in all areas of textile work, and we will be looking at the style and substance involved in creating and representing them. The context for creating birds and insects will also be examined as will three-dimensional design.

Chapter 4: Working with Green Spaces continues the theme of connecting with your local environment and making the most of the resources available. My work and other artists' residencies in gardens in the UK will be explored, and we will look at taking your own work beyond your locality.

Chapter 5: Nature in Context looks at how subjects from nature can be used symbolically or as a jumping-off point for further ideas. I look at the work of practitioners who subvert the themes of nature to send a message, as well as examine some ideas for working when travelling.

My aim in this book is to enable textile artists and students of all ages to find inspiration and ideas.

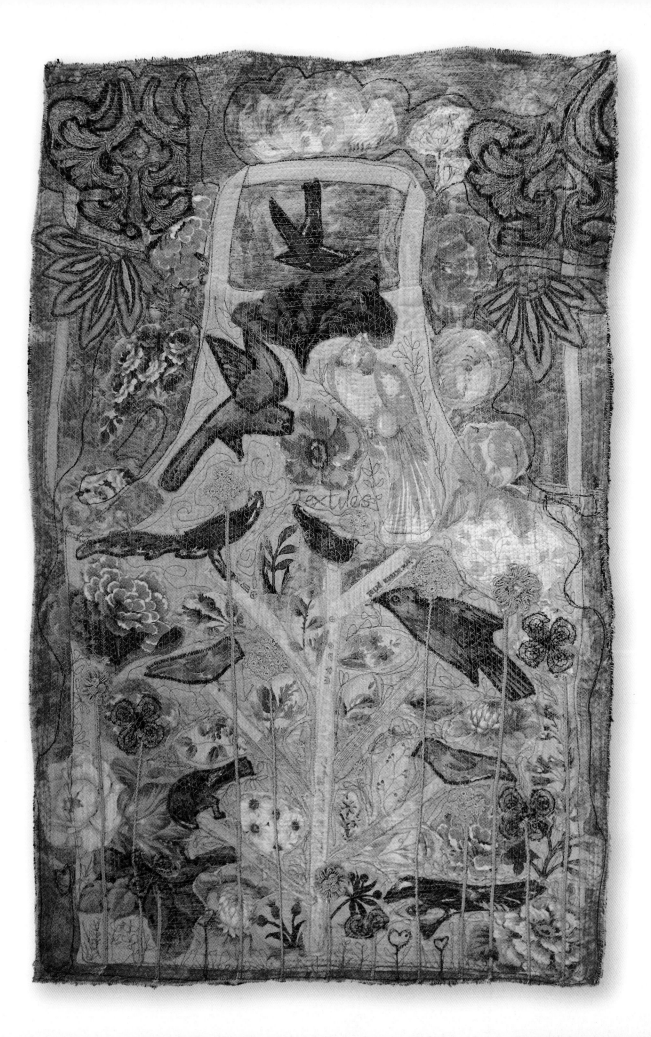

Drawing from nature

'Great art picks up where nature ends.'
Marc Chagall

Drawing from observation

Nature really is the best teacher. It is much more difficult to make up or imagine an object from the natural world than it is to observe it from life. Creating a studio or work environment where inspiring objects are close to hand greatly helps with the creative process. The traditional 'nature table' has been a starting point for many students and echoes the cabinet of curiosities dating from medieval times. I have rercreated a contemporary version of it in my studio.

Baroque Ceiling by Anne Kelly.

A nature table in my studio

A nature table is a common element in many of our childhood memories. It is used in primary schools to introduce children to elements of the natural world. A range of found seasonal items, such as leaves, acorns, feathers, shells and plants can be placed together and the table allows children to identify and become familiar with seasonal objects and to handle them. Many artists employ a similar method to display and work from inspiring items collected in their daily life and travels. My studio is in my garden, not far from the house but far enough away to be able to observe the changing seasons and foliage

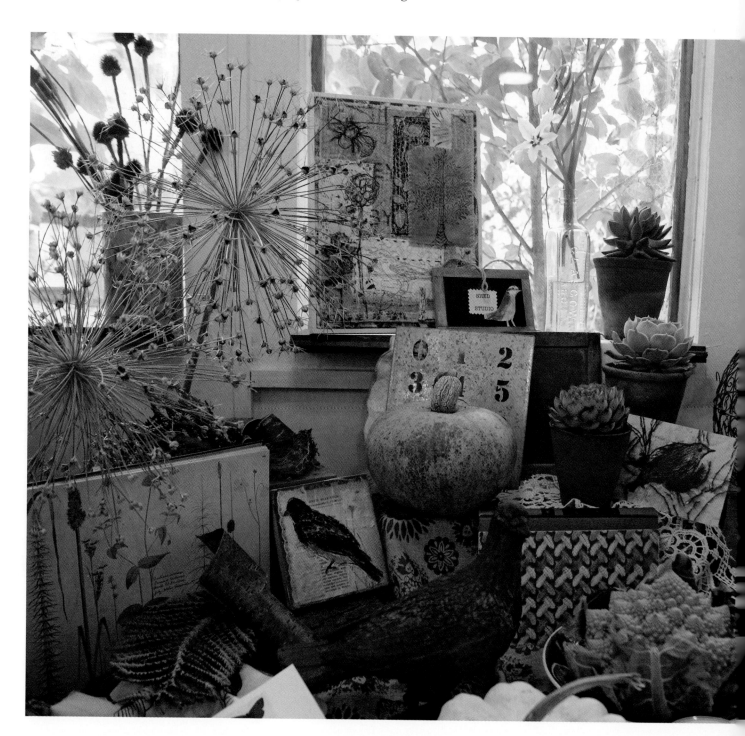

up close. The windows give sufficient light to work without artificial light most days. I enjoy collecting unusual objects with students who use my studio and I have assembled some of these in a display with seasonal flowers and plants. I'm drawn to vintage fabric and ephemera so these are included. This provides several opportunities – to be able to draw from objects, either singly or in groups. The objects themselves are interesting enough but the patterns and structures found in them can also be used in a variety of ways.

The nature table in
the author's studio.

What you can do with one plant...

Bay embroidery
by Anne Kelly.

Bay is from an early series of embroideries based on the plants in my garden. I chose plants that I could see from my studio and embellished them with colours and textures that fit the theme. Taking the bay leaf (or any garden plant) as a starting point, you can create a range of work using a series of different techniques.

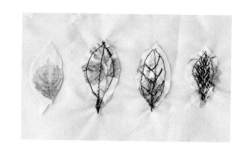

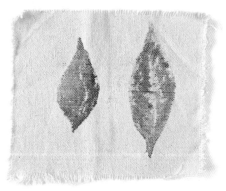

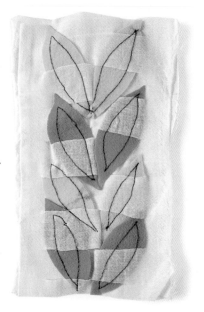

• **Stitch** (appliqué and embroider): using a variety of coloured fabrics, cut out a leaf shape from one of the fabrics and appliqué it onto a background, stitching in the details of the veins and embellishing it with a mixture of hand and machine stitching.

• **Print:** make a template from the shape of the leaf and use it to create a repeat print design. Shown right is a Gelli© print, taken from an actual bay leaf. Although it is possible to make monoprints without Gelli© plates, these do give a crisp and clean print. Roll the Gelli© plate with acrylic paint and a roller/ brayer and lay your leaves into the painted surface. Remove gently and place your fabric over the plate. Roll with a dry roller/ brayer and remove the print.

• **Dye:** mix up a variety of green dyes to paint the leaf outline, shape and detail onto fabric. Then overstitch and paint in. I use non-toxic Brusho© dyes, which are fine for work that will not be worn or washed. The colours are not as vibrant as Procion© dyes, but they are naturalistic and good for painting on cloth. I mix the quantity I need into paint wells in a palette and use the colours required, mixing them as I go.

• **Weave:** use the leaf shapes to create a Japanese-inspired screen. Cut bay-leaf shapes out of felt, tracing around the shape of the leaf, and using an over/under weaving method, work into a cut fabric background, arranging in a pattern of your choice.

Emma Nishimura

Looking at leaves, either singly or in groups, can be rewarding as you discover their intricate and individual structure. I was inspired to make a miniature screen after seeing the work of Emma Nishimura at the World of Threads Festival of Contemporary Fiber Arts near Toronto, Canada. She created a beautiful sculpture, *Shifting Views*, using small leaf shapes, wire rods and soil to create a field of reeds.

Detail from *Shifting Views* by Emma Nishimura.

Emma says about her work: '*The silhouette of a mountain and a cloudy sky: a photographic record of the present, at the site of the past. When viewed from afar, this piece evokes the memory of a landscape, yet upon closer investigation, it's actually a field made up of hundreds of reeds. A study in duality and all that lies between, the past and the present, the concrete and the intangible, the fleeting and the grounded, this piece is part of my ongoing exploration into the myriad layers contained within a story. Working with an image taken from the landscape in which my grandparents lived during their internment as Japanese Canadians in the Second World War, a vista has been re-created and a memory rooted. Yet from all angles, this piece offers only a shifting, fractured reading; nothing is complete or whole, just as no story is ever fully experienced, told or remembered.*'

Going large

Often you will want to start small, as in the samples on page 12, but a lot can be gained from supersizing your work, even in the early stages of exploration. This will drive you towards studying the details of your subject, perhaps using a magnifying glass or photographic enlargement. It can also produce some dramatic and stunning pieces, as in the work of Pauline Verrinder and Meredith Woolnough, shown here.

Pauline Verrinder

Pauline is a well-established tutor and embroiderer, based near Cambridge, England. I was fortunate enough to meet her when teaching in Bedfordshire. She was making leaves, embroidered on a stretched scrim support and embellished on the sewing machine. The delicate veins of the leaves come through in her work and, when finished, the leaf is a strong enough shape and form to be presented by itself.

Pauline describes her piece: *'Natural forms are the inspiration used for the wired leaf shown in this image. Shapes are formed using cotton-covered wire. The leaf shape is applied to framed cotton scrim using free-machine embroidery set to zigzag (width on 4). Edges and veins of the leaf are covered closely with zigzag stitch using a cotton thread. Using the same machine setting, I randomly scribble on the scrim to give a distressed look to the leaf. To finish, the formed shape can be coloured with silk paint or Dye-Na-Flow© and heat set.'*

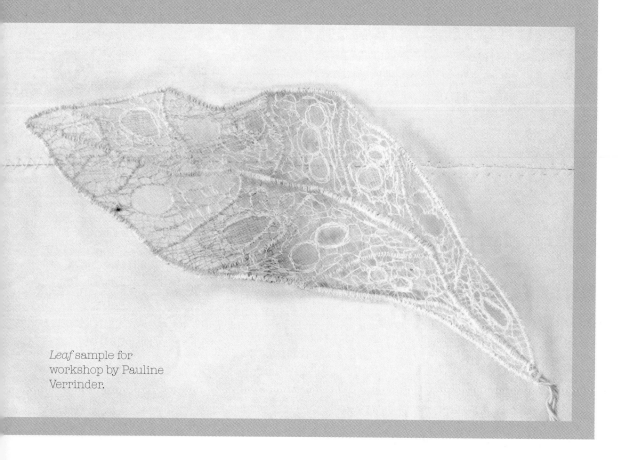

Leaf sample for workshop by Pauline Verrinder.

Meredith Woolnough

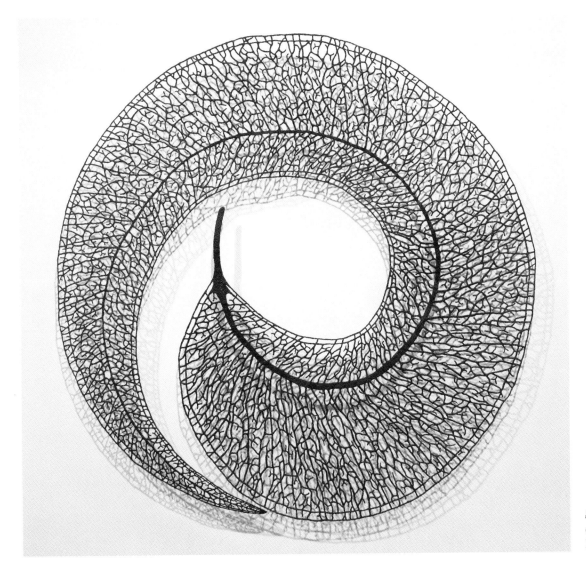

Scribbly Gum Leaf,
embroidered textile by
Meredith Woolnough.

Meredith is an artist working in New South Wales, Australia. She writes about her work: *'I have always found inspiration in the natural world. I am lucky enough to live close to both coastal and bush land environments so I get to visit various habitats frequently. Exploring, collecting and drawing makes up a large part of the fieldwork aspect of my practice and I like to research any plant or animal thoroughly so I understand it before I translate it into stitches. I am also a keen scuba diver so I love to explore the world below the waves as well. I have always been fascinated by the structure of things, from the hard shapes of coral colonies to the minute arterial veins in leaves. I like to draw parallels between the growth and life systems of various organisms in my work commenting upon the interconnectedness of all living things. My process involves using a domestic sewing machine as an unconventional drawing tool. I employ a similar process to traditional machine darning or the more modern name "freehand machine embroidery" where the feed teeth are turned off, giving you complete control about how you move the base fabric under the needle. I use a water-soluble base fabric to create my work and once my embroidered design is complete I simply wash it all away in hot water to leave my skeleton of stitches behind.'*

Sampling nature

While you are studying your subject, don't just think about its form – consider its texture too. You could utilize some of the many traditional embroidery stitches for this, both from your own culture and others. Think outside the box if you can. Do you have any fabrics or other bits and bobs that could be incorporated to convey texture and form?

Tunbridge Wells Embroiderers' Guild

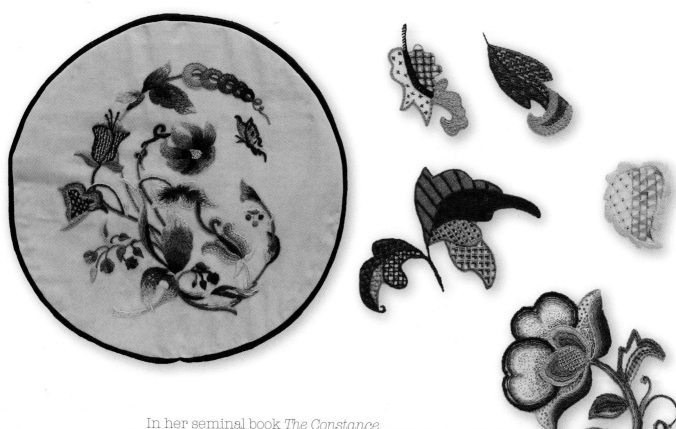

In her seminal book *The Constance Howard Book of Stitches*, the well-known author and tutor Constance Howard worked in co-operation with the Tunbridge Wells Embroiderers' Guild. The book is a wonderful compendium of sample stiches and instruction, but also, more importantly, detailed interpretation.

A more recent project undertaken by the guild has been an A–Z of techniques. Many of the stitches are based on natural motifs; plants, grasses and landscape. The project also examines tones, textures and threads as well as the more practical concerns of needles and techniques. I was fortunate enough to be able to look at these actual boards, through the loan of their Chairman Carole Barter, and to photograph them afresh for this book.

Lizzie George

Lizzie is an artist and teacher living in a small village in West Sussex, England. She is inspired by the local landscape and nature and produced this canvas of plant forms for a fund-raising exhibition for a local hospice. The plant forms are appliquéd and machine embroidered with couching on linen union. The work was then stretched onto canvas.

Wildflower Sampler, mixed-media embroidery on linen union by Lizzie George.

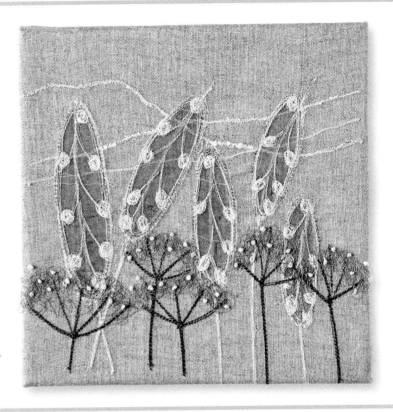

Coei O

A former student from Hong Kong who went on to study at Central St Martins in London, Coei O set herself the task of making a sample sketchbook with stitch examples to plan one of her coursework projects. Her samples are beautifully worked and show how well-presented and defined stitching can become an artwork in itself. They are primarily based around plant and flower motifs and are echoed in the design for her final piece.

Pages from Coei O's sketchbook.

The landscape of home

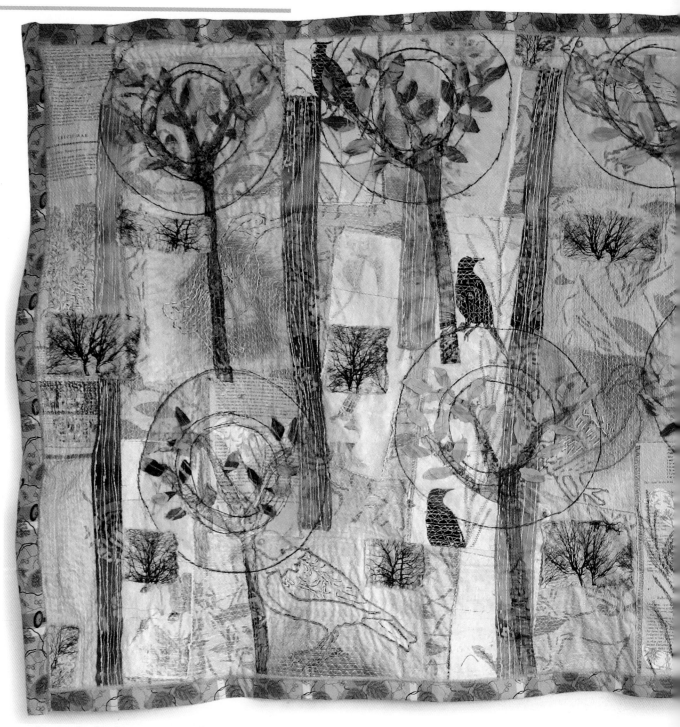

Our connection to the landscape surrounding us helps to shape our identity from an early age. I live in Kent, in the south-east of England, where the landscape is a mixture of rolling hills, downland, forest and chalky seacoast. Representing all of this in one textile would be impossible, so when instructing my students I often advise them to focus on an aspect of the landscape that particularly interests them. The piece above, for example, which was for an RSPB centre, focuses on birds and trees.

Background for *Sparrow Stories* by Anne Kelly - see pages 84–85.

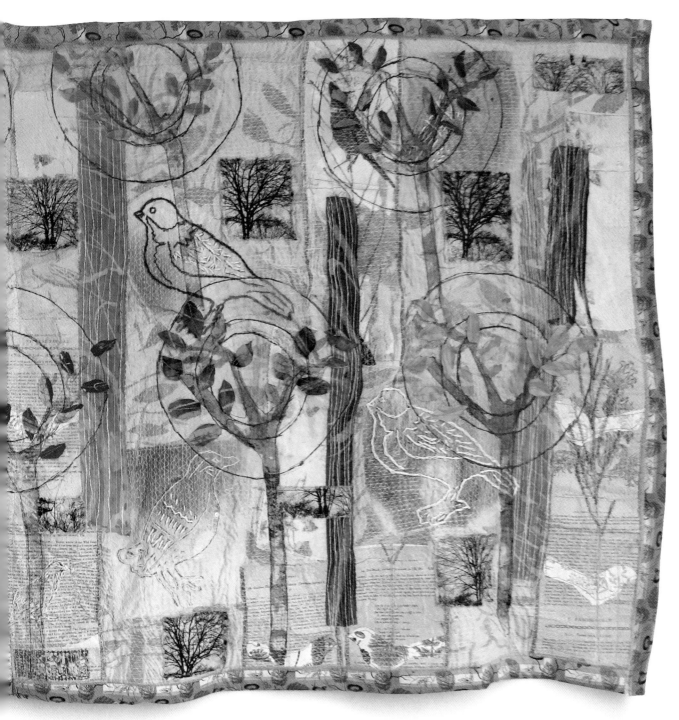

A student, Susannah Fenn, was learning how to use a free-motion embroidery foot (see sample, right). She was working on a large drawing of a crow on linen union and using black cotton on the top and bobbin of the machine to create a delicate line. The range of marks she has created is remarkable for a first attempt and emphasises the link between drawing and stitch, a theme that I will be returning to throughout this book.

Student sample of free-motion stiching on linen union.

Cas Holmes

In her folding books, Cas uses scraps of fabric and paper, Japanese tissue and paste to create translucent surfaces. She then draws and 'stitch-sketches' over them, often recording snippets of her surroundings – unconventional observations such as dead birds and the detritus of polluting humans. This emphasises her connection to nature.

Cas says: *'We take for granted the diverse flora and fauna our seasonally changing landscape and varied habitat gives us on such a small island. This piece reflects the transient change of the Norfolk coast and fenlands. Printing directly with foliage and referencing patterns in the wet earth, I am looking "under and above the soil" for inspiration.'*

Fenland, mixed-media textile by Cas Holmes.

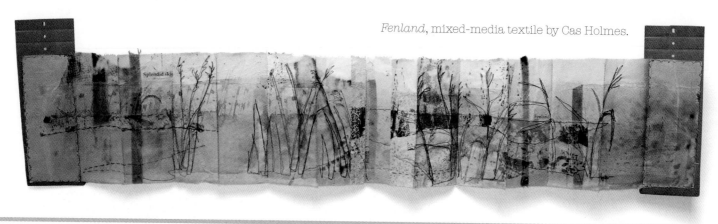

Carol Naylor

Radiant Light, embroidered textile by Carol Naylor.

Carol is an experienced and well-known machine embroiderer, and has made the interpretation of landscape her own area of expertise. Her textiles are densely worked, always studied directly from life and very personal.

Carol says: *'I look, I draw, I select and I translate. Sometimes I simply rely on the memory of shapes or colours observed. It can be enough to launch a series of works. I constantly revisit my sketchbooks, and one drawing can be reinterpreted in many ways.*

My abiding passion is landscape. What really interests me is the way in which the surface of the land changes wherever I am. I look constantly for evidence of both the underlying structures within natural land formations, and the surface patterns and textures created by seasonal changes and cultivation...

Melvyn Evans

Landscape with Blackbird, linocut by Melvyn Evans.

Melvyn is a designer and printmaker who lives near Sevenoaks, in Kent, England. His work follows in the tradition of inspirational mid-century designer/printmakers such as Eric Ravilious, who simplified and condensed the landscape into recognisable elements. Melvyn uses lino blocks, which will be looked at on page 22.

He says: *'I'm fascinated by connections between aural traditions and the British landscape. There is a sense of prehistory in old place names and early monuments. I generally start with small drawings and some of these ideas I scale up into larger drawings. I'm very interested in composition, creating a flow through the image. Once I'm happy with the drawing, I reverse it and transfer it onto the lino ready to start cutting. I use a separate lino block for each colour; the colour separation being worked out at the drawing stage.*

For me there is a very close relationship between the printmaking process and drawing, in that I am asking a limited number of colours to achieve a desired effect without the use of a key block. My prints rely instead on a balance of shapes and tones worked out through repeated drawings.

As this series has developed I have used texture to soften the graphic look that is so characteristic of linocuts and to impart a more painterly quality to the final image. The use of texture also introduces an element of chance.'

I draw and develop ideas from first-hand resources, exploring qualities of light and shade, line and colour. I work mainly with heavyweight threads that are too thick to go through the eye of the needle, so these go underneath on the bobbin (spool). I turn the piece over and work from the back of the canvas. The top light, normal thread then "couches" the heavy thread underneath so that when I turn to the front again I have created long lines rather than individual stitches. It's just like drawing with the sewing-machine needle, providing the marks that a pencil or pen would make and the richly coloured threads offer a wide and exciting palette.'

Flocked lino samples

Taking inspiration from the graphic impact of printmaking, I have returned to a more traditional method of printing on fabric. Flocked lino is a wonderful material as it gives you defined shapes and the carved block can be mounted onto plywood to create a more permanent printing block.

Start by drawing your image onto the flocked lino, using a white-coloured pencil or crayon. Remember that your image will be reversed and that you are cutting out the negative shapes and leaving the positive lines. I have chosen a simple flower motif to print onto fabric. I use standard lino cutting tools to carve into the block. As well as creating a textured look, flocked lino is easy to cut so it is a great choice for beginners. Once I have printed my sample, using a roller and acrylic paint or thick fabric paint, I will embellish the piece and use it in a larger work.

The graphic potential of the flocking itself can be inspirational.

Flocked lino cut (centre) and prints (left and right) by Anne Kelly.

Justine Head

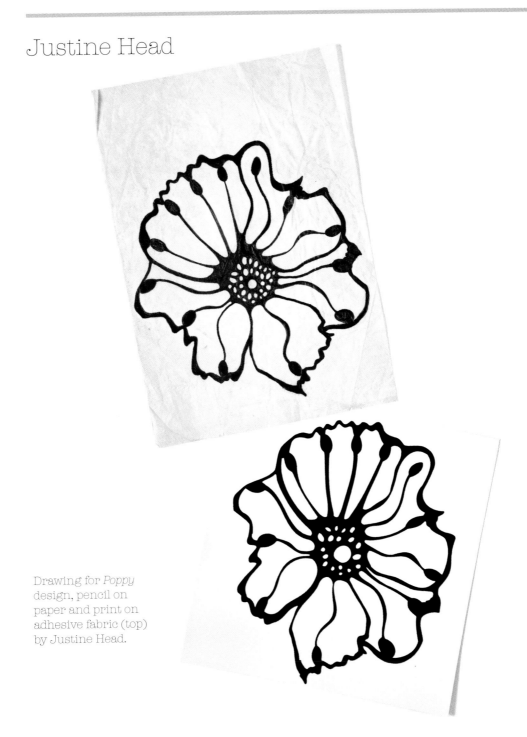

Drawing for *Poppy* design, pencil on paper and print on adhesive fabric (top) by Justine Head.

Justine is a foundation and degree tutor, former tutor at London College of Fashion and a fashion trained textile artist. She recently took a sabbatical from teaching and moved to Le Marais in Paris, a hub of creativity and innovation in the city. She was commissioned by The Collection, an interior design shop in Paris, to produce the floral stickers and some were used in the Christian Lacroix hotel, Le Petit Moulin. These were taken from her drawings of real flowers and are simplified forms and powerful statements within their own right. They are laser-cut from original drawings onto adhesive fabric and then peeled and positioned into place. Her designs were some of the first to be created using this now very popular technique.

Organic shapes

Organic shapes are all around us, from the undulations of hills and valleys to the wonderous curves of leaves and petals and even right down to the details of individual cells. A collaboration with printmaker Jenifer Newson looked at blood cell structure under the microscope. I made a series of hanging panels, each based on different cell names and exhibited these in my solo show at Farnham Maltings in Surrey, England. More recently I decided to return to the theme with a new series of work.

Lymph nodes

I was drawn to the shapes of these lymph nodes following some investigations and found their complexity intriguing. Using a combination of canvas and net, I created a dyed and hand-coloured background. I then drew the shapes of the nodes over the top of the background, using a fine line waterproof pen. I finally used free-motion embroidery over the drawings, using a darker thread. The pieces were suspended in panels in a similar way to the previous series.

Red Blood Cells (left) and *Lymph Nodes* (right), mixed-media textiles by Anne Kelly.

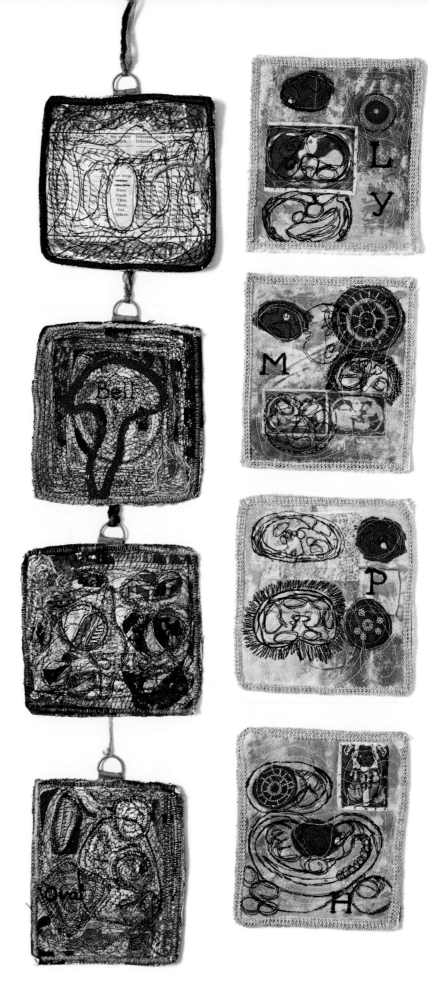

Kim Thittichai

Stones, mixed-media textile by Kim Thittichai.

Kim is an internationally known artist, author and tutor. Her books are renowned for explaining in clear terms the complexities of working with textiles that respond to heat interventions. As a brand ambassador for a leading manufacturer of fusible interfacings and soluble fabrics, she is an expert in their application. One of Kim's favourite locations is New Zealand, and she has made work reflecting her affinity with the landscape.

She says: 'Stones *was created on a course with Gwen Hedley and was run by the Textile Study Group. First of all the group were asked to make a few basic, small drawings – nothing too frightening. We then made printing blocks from one of the drawings. I chose my stones drawing; I like strong, simple shapes. After making the printing blocks the group printed up their fabrics, taking the colours from the drawings. I used viscose satin and cotton organdie. Having made several prints using the same colour tones I was able to choose the best three prints to create my sample. I decided to lay printed cotton organdie over viscose satin and cut sections out. I then cut other sections out from my third piece of fabric to apply shapes onto my sample. I used Bondaweb© on the back of the small pieces and ironed them in place. I then used backstitch to define the lines of the print and the shapes and used colours that were in the work.'*

Planting in cloth

'...everything in nature is coloured.'
Paul Cézanne

Leaves and trees

Reflections of nature can start with the basic outlines and silhouettes that we see around us – leaves and trees are a good place to begin. This chapter gets underway with a look at how several artists – including myself – have made use of leaves and leaf shapes, all in very different ways.

Old Colonial Bird Tree,
mixed-media textile
by Anne Kelly.

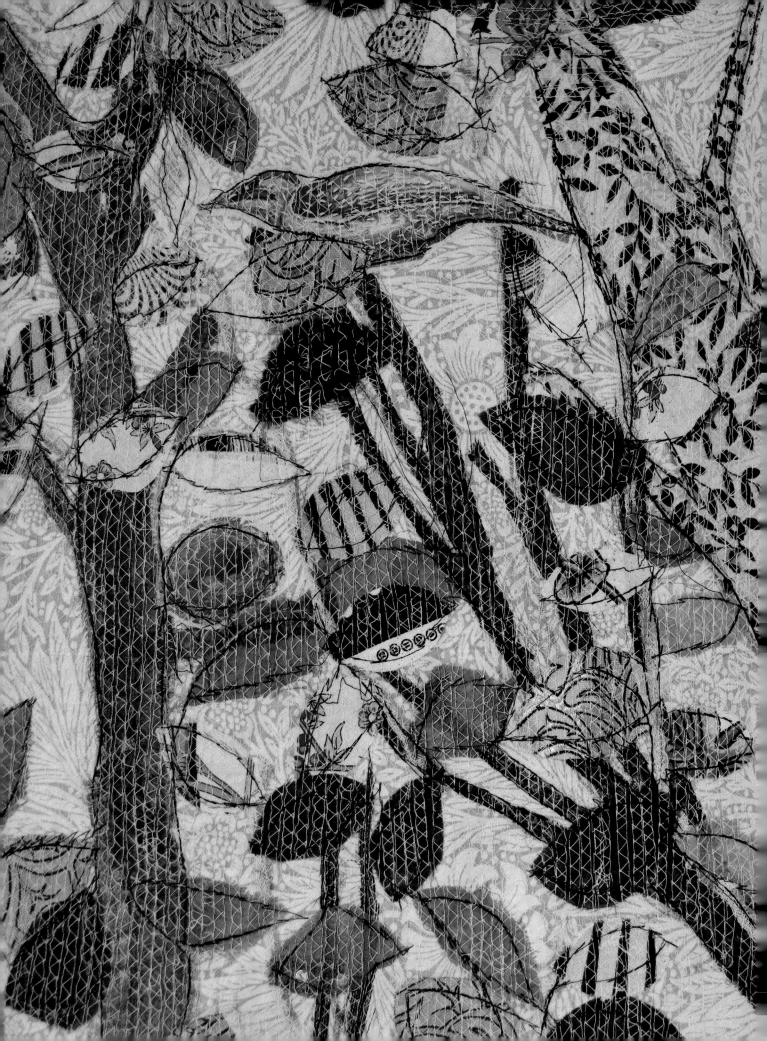

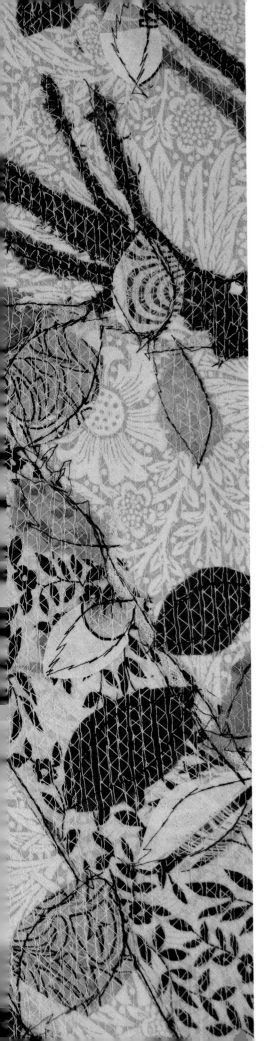

William Morris Trees

In autumn 2013 I was approached by the arts coordinator at the Tunbridge Wells Hospital in Kent, England, about exhibiting in one of their corridor galleries. The multi-faith centre at the hospital was also identified as an area in need of some artwork and I was commissioned to create two hanging panels for the room. The hospital is surrounded by trees; some older and some newly planted. The coloured glass in the centre is blue and green so I wanted to incorporate this scheme into my design. I started with two large drawings of wooded areas, taken from the ground looking up. I used a background of William Morris printed upholstery fabric, found in a charity shop. I then drew my designs directly onto the fabric and used a combination of florals and plain designs to appliqué the tree shapes onto the background. I overstitched the edges of the trees and branches and added leaves in a mixture of colours. There are also birds perched in and around the branches – these were designed on separate pieces of fabric and added into the piece. I used a simple stencil motif of a tree and an Indian tree printing block (see page 50) to make a border for the top and bottom of each piece. The borders were added after the main piece was finished. Each piece was backed with a vintage Sanderson upholstery fabric of oak leaves and hung from metal rods. As the pieces do not contain specific religious imagery or iconography they appeal to visitors of all faiths and none.

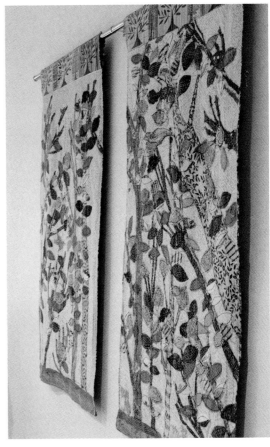

Left: Detail of *William Morris Trees*, mixed-media textile by Anne Kelly.

Right: *William Morris Trees* hanging in situ at Tunbridge Wells Hospital multi-faith centre.

Working with plants

Plant motifs surround us and it is inspiring to look directly at plants and their shapes in nature, as Alice Fox and Helen Ott have done in the following works. Other artists, such as Hillary Fayle and Carmen Li, have taken one step closer to nature and work directly with plant material itself.

Alice Fox

Alice has a unique, almost forensic approach to her work. I taught alongside her in North Wales and saw first hand how she sets up a studio/laboratory space, full of exciting experiments and projects. Her relationship to the natural world is implicit.

She says: *'I have always been fascinated by the natural world and the detail of organic things. My practice brings together recording, collecting and interaction with the landscape. The work that I produce celebrates and carries an essence of what I experience in the natural world. I aim to draw the viewers in, invite them to look closer and notice things they might otherwise have overlooked. I am concerned with embodiment of the landscape rather than direct representation. Each piece can be seen as a small record of a walk: a journey or moment from a journey. The works I produce are contemplative and quiet, but look closely and you'll discover there is complex activity; patterns can appear both random and organised. Look again and there is something new to discover.'*

The piece reproduced here is *Leaf Lexicon*, a series of impressions of leaves taken from 'A Language of Leaves', works loosely based on thoughts about asemic writing and the forms that leaves make when they fall and are arranged on the ground. Asemic writing can suggest meaning but is open to the viewer's interpretation.

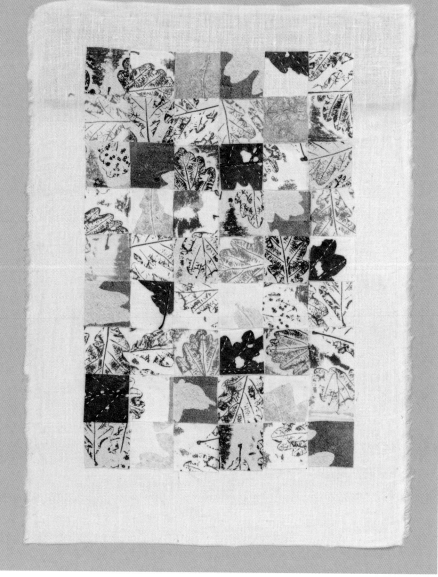

Leaf Lexicon,
mixed-media textile
by Alice Fox.

Hillary Fayle

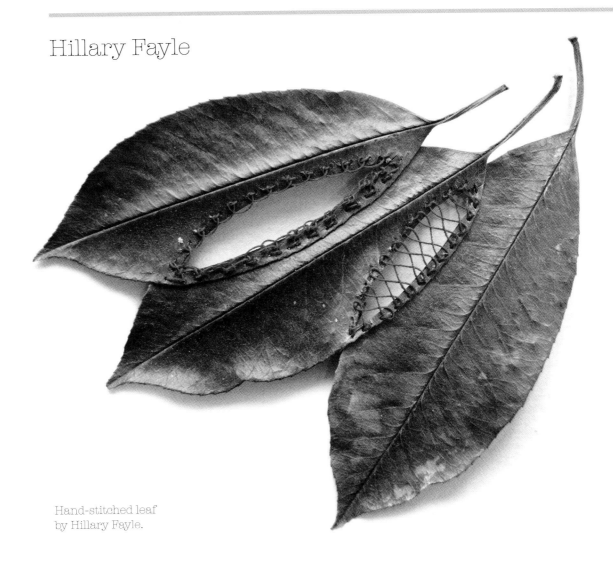

Hand-stitched leaf
by Hillary Fayle.

American textile artist Hillary Fayle describes her process: 'I use found botanical material such as leaves, seedpods and branches to explore human connection to the physical world. By combining these organic objects with the rich traditions of needlecraft, I bind nature and the human touch. This gentle but intricate stitch work communicates the idea that our relationship with the natural world is both tenuously fragile and infinitely complex. The objects that I find in the physical world serve as a great inspiration to me. Perfect in their imperfection, they tell me stories of their existence. I regard these leaves, twigs, stones, bones, feathers and all that may have happened to them; the events that had to unfold to lead them into my hands. As I decide how I will interact with each, I relate its history, real or imagined.'

Carmen Li

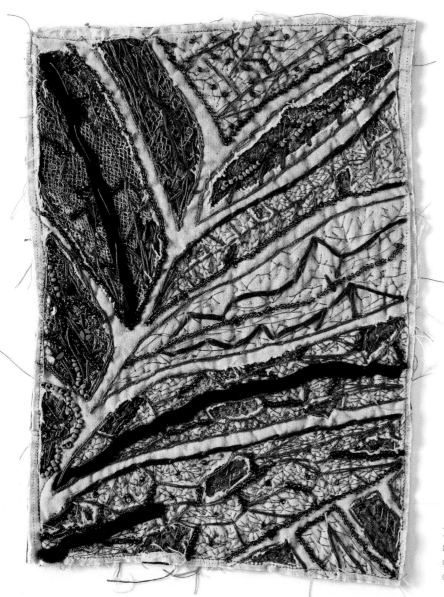

Hand-stitching sample, embroidery cotton and beads on calico by Carmen Li.

This leaf is a student piece, exploring different ways to decorate and embellish a leaf outline on fabric. Carmen started with a closely observed drawing of a maple leaf. She drew the outline onto fabric and embellished the main areas of the leaf with a variety of stitches and beading. The tonal values of using different shades of green make it unique and add interest to the overall piece.

Helen Ott

Helen is a local textile artist and student who has lived in Japan and has a great appreciation of Japanese fabric and stitch: *'I have been collecting small precious pieces of old/antique Japanese fabrics for years, fascinated by how they feel and look: soft, faded, worn, treasured. I sew my pictures by hand, using Japanese threads and sometimes having to stabilise the fabric carefully if it is too delicate to handle. We lived in Tokyo for some years and I was lucky enough to meet various Japanese artists and be guided to study others who work with textiles. My recent pieces have all been heavily influenced by the Sensei, the concept of Wabi Sabi and the effective simplicity of Japanese design.'* In her piece *Anemones*, Helen uses the subtle variations in tone to advantage, capturing the fragility and unique shape of these delicate flowers.

Anemomes, Japanese fabric appliqué and hand-stitch by Helen Ott.

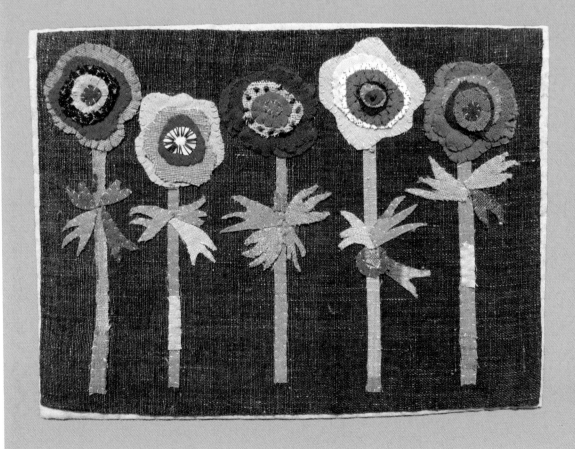

Wildflowers

Wildflowers are not only an attractive subject but also a very topical one – as the world starts to realize that these very special plants are under threat, efforts are being made to protect their ever-dwindling habitats. The threat of loss makes these flowers all the more poignant.

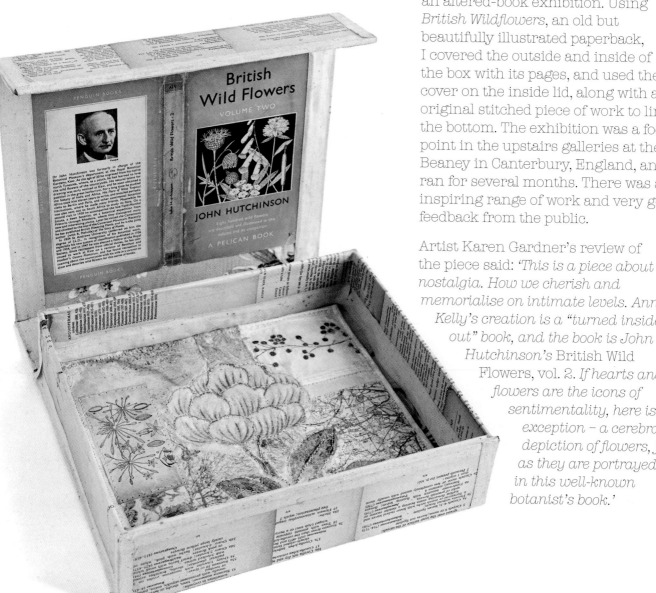

Wildflower Book Box, mixed-media textile and archival card box by Anne Kelly.

Wildflower Book Box

I made this constructed book box as a response to an open call for submissions to 'Alternative Stories', an altered-book exhibition. Using *British Wildflowers*, an old but beautifully illustrated paperback, I covered the outside and inside of the box with its pages, and used the cover on the inside lid, along with an original stitched piece of work to line the bottom. The exhibition was a focal point in the upstairs galleries at the Beaney in Canterbury, England, and ran for several months. There was an inspiring range of work and very good feedback from the public.

Artist Karen Gardner's review of the piece said: *'This is a piece about nostalgia. How we cherish and memorialise on intimate levels. Anne Kelly's creation is a "turned inside out" book, and the book is John Hutchinson's* British Wild Flowers, *vol. 2. If hearts and flowers are the icons of sentimentality, here is the exception – a cerebral depiction of flowers, just as they are portrayed in this well-known botanist's book.'*

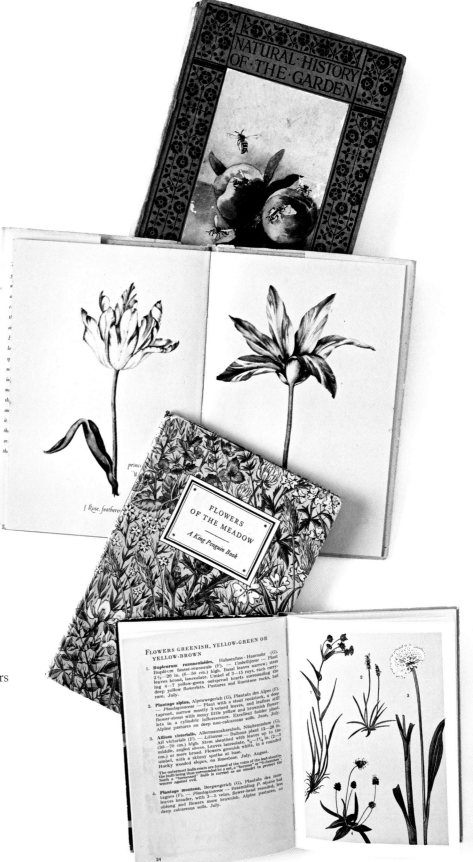

Vintage books: herbals

Old books of wildflowers and herbals
are a great resource. Often they show
simplified images and diagrams of
flowers that are useful for drawing and
designing motifs. I keep a look out for
these in charity shops and at booksellers
where they are often overlooked. The
books show a diverse approach to
representing flowers and identifying
their characteristics.

Transfers and collage

There are many ways of using floral imagery and transferring it onto fabric. For example, the use of T-shirt transfers on fabric has become much easier as the technology has improved. Transfers have lost their stiff and waxy feel and they are much thinner and 'invisible'. I like to use them and cut out shapes to add into other pieces. You can use them in any inkjet printer. This is the method:

1 Choose an image that you would like to transfer.

2 Place the image in the scanning/ photocopying area of your printer and load the transfer paper (check which side up the paper goes in). Also note that you will have to reverse any writing on the image using a program on your computer, as the image will come out back to front once transferred.

3 Copy the image and print it out, wait until the ink is dry and then follow the instructions on the package for ironing the transfer onto fabric. It is crucial that the iron is the right temperature and that you protect your ironing board and iron; baking parchment is good for this.

4 Your transfers can now be embellished and overstitched as part of a larger piece of work.

Wildflower Sampler, mixed-media textile collage by Anne Kelly.

Louise Pettifer

Louise was the artist-in-residence at Sissinghurst Castle Garden in Kent, England. She worked on a series of flower pieces connected to the garden. Using a combination of techniques, developed since her training as a textile designer.

She says: *'I start by choosing a plant or flower to study. Once I have made my drawings and I'm back in the studio I can begin one of my layered works. I cut several lino blocks and create a unique one-off print (a monoprint) by printing them in several layers. The next step is preparing the collage papers, using a range of painting and printmaking techniques. Once I am happy with the colours and textures of the papers, I cut them by hand, following the outlines of my original drawings. The cutting is a delicate procedure, which takes many hours and a steady hand. I usually add a layer of line drawing, using inks, and finally, apply the paper cut elements to the surface.'* These drawings of roses are delicate and beautifully cut, and could equally be printed onto fabric. Louise's method of working in layers could be used for sketchbook work as well as finished pieces.

Rose Garden, mixed media by Louise Pettifer.

Paper and card cut outs for *Rose Garden*.

Roses I, mixed-media textile by Val Holmes.

Val Holmes

Roses, mixed-media textile by Val Holmes.

Val is one of the UK's best-known writers on textiles and textile artists. Now living and working in France, she teaches and exhibits both sides of the Channel. She says: '*Gardens and landscapes are a big source of inspiration for my work, and my own garden, now full of roses, is an important source. Having seen a professional garden where the roses were allowed to run wild, I now (almost) do that with most of mine, and the results are pretty good. The image Roses I is a monoprint worked with Manutex and Procion dye on glass and printed onto calico. It is then embroidered by machine. The second image Roses is the second print off the same monoprint, which has been embroidered a little less. The aim in my work has always been to work towards a level of abstraction – abstract realism if you like, with lyricism. Using monoprints as part of this process allows me to dye work that is almost automatically less exact than if I were to paint it. I can then experiment with the same or very similar image in a number of ways, thus pushing further my learning process.*'

Incorporating flowers

Working with flowers and floral motifs as the central image can be inspiring, but inserting flowers into a composition or using them to build up a background can also enrich your work. Here I have integrated embroidered flowers and printed and metallic fabric into a base image. I have then 'drawn' over it with free-motion stitching to add flowers and a bird.

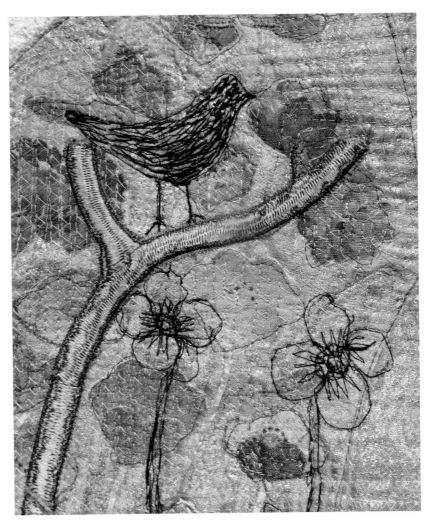

Detail from *Natural History Waistcoat* by Anne Kelly.

Drawing flowers in stitch can also be a natural extension of sketchbook work. In this detail from *Suburban Gardens* I have used layers of floral imagery in the background and then free-motion stitch over the top. Some hand stitching is also added for depth.

Detail from *Suburban Gardens* by Anne Kelly.

Wildflower Tea-cloth Sketchbook

After my residency at Sussex Prairie Garden in West Sussex, England, I wanted to record my time there with a cumulative piece, based on sketchbook studies from the garden. I had a collection of tea cloths, which I had patched together and used for covering the 'wagon studio' at the garden (see page 90). I decided that with their delicate floral borders and lacy edges these would make an ideal backdrop for my drawings. I traced the drawings from the sketchbook onto the back of the tea cloths, and used free-motion embroidery to outline them. When I had completed the series, I added birds, also taken from the sketchbook. Some small embroidered pieces of cloth and shisha, taken from an Indian textile, completed the piece. I backed the piece with a vintage furnishing fabric. It was the centrepiece of my work at 'Cross-Pollination', a group exhibition featuring artists-in-residence at three different gardens, and as part of the Chelsea Fringe. I also used photographs taken from the sketchbook and piece to create a small photo picture book.

Wildflower Tea-cloth Sketchbook, mixed-media textile by Anne Kelly.

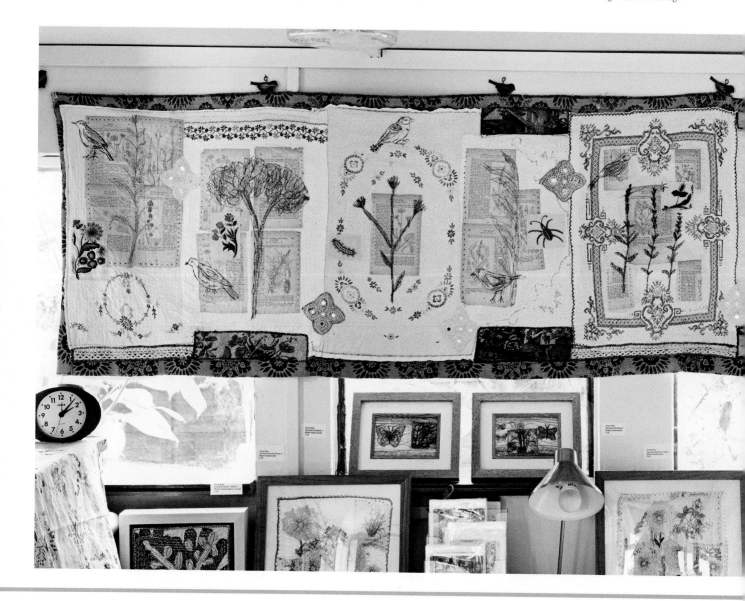

The photo picture book created using photographs from the sketchbook.

On a much smaller scale, textile work can represent a meadow or grouping of flowers beautifully.

Emily Notman

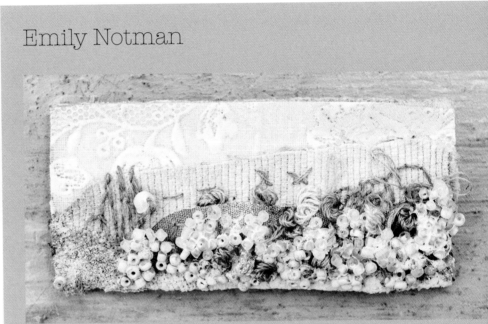

Meadow Brooch, mixed-media textile by Emily Notman.

Emily makes beautifully dense fabric collages and pieces, like this *Meadow Brooch*, which often incorporate plants and flowers as part of a larger composition. Emily has written about her work: '*I create bespoke textile installations mixing media and building up tactile, delicate surfaces. I work and rework my pieces with paint, dyes, bleach and ink, burning and layering until finishing it with hand stitch. I find beauty in flaky walls, overgrown buildings and encrusted surfaces (this is something I re-create in my work). My pieces evolve and grow with time, incorporating history with layering, and sometimes the tiniest mark or stitch changes a piece dramatically – it's this detail that excites me. The diversity of stitch is key in my work from loopy, loose hand stitch to fine, subtle rows of machine embroidery. I have a range of yarns, wools, machine threads and embroidery cottons to work with. I work with the chunky thick yarns first, building on the marks made with paint. I then decorate with delicate fine loops. A piece could then be entrapped with netting or lace, which then acts as another surface to build on.*'

Mid-century influences

Looking back at historical designs and cloth work is an established practice for designers on the lookout for inspiration. I have a fondness for mid-century design, due to my upbringing and the decor/surroundings around during my childhood in Canada. I am delighted to see it make a comeback and that it is widely celebrated and given a contemporary twist.

Allotment flowers (sweetpeas).

Pattern and print

Textile pattern and print is dominated by floral images. From early experiments in block printing to today's digital technology, flowers are everywhere.

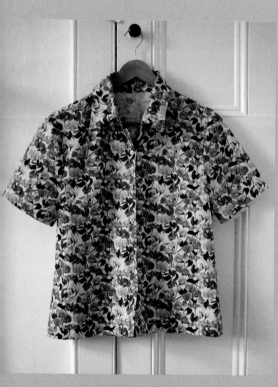

Melanie Bowles' sweetpea design (digital print on fabric).

Melanie Bowles

Slow Grow was an innovative project by Melanie Bowles, Senior Lecturer at Chelsea College of Arts and co-author of *Digital Textile Design* and *Print, Make, Wear*. She is also the co-director of the creative enterprise The People's Print with Dr Emma Neuberg. Melanie describes the process: '*Slow Grow creates a design model for the wearer to be at the centre of the design process to create a textile and garment unique to them, reflecting their character and environment. Slow Grow follows the journey of grower to wearer (Mary). Mary is passionate about her Fulham allotment, and growing her flowers and produce is important to her well-being and happiness. Mary's creativity is translated into a sweetpea design, which is printed and made into a shirt. Mary is central to the design process and aims to create a slow fashion piece to create a long-life garment that is unique to the wearer. Slow Grow encourages participatory design by engaging the wearer through the journey of creating her own printed textile and garment by placing her at the centre of the design process, working with design concepts of slow design and emotional durable design, and using local digital print bureaus and dressmaking patterns for production.*

Alison Milner

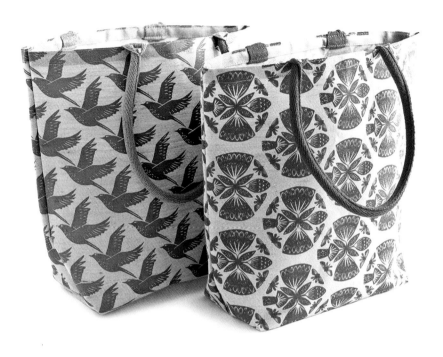

Alison describes herself as 'a designer of two-dimensions for three-dimensions', working from the south coast in the UK. Her work incorporates transfers onto a variety of surfaces as well as using print processes. She taps into a 'mid-century' aesthetic, with a contemporary edge: *'I was asked to develop some products for the shop at Rathfinny Estate, Alfriston, in East Sussex. The shop was not yet bought and the sparkling wine vineyard was only just being planted, so it was really interesting to see everything happening. I was asked to develop a whole range of products... I started by designing twelve "iconic images" chosen in collaboration with the owners to represent the vineyard. Six of the images were photographic and six graphic. We also chose six colours; based on the colours of the landscape and wild flowers. The two images used on the bags pictured were a stylised kidney vetch (actually yellow but printed in poppy red) and a skylark (printed in pale sky blue). Kidney vetch is the sole food of a rare blue butterfly found on the estate. We sourced a very nice juco (jute and cotton mix) bag that is made in India. The images on the bag are silkscreen printed so my graphics were ideal for that.'*

Alison Milner's textile bag design for the Rathfinny Estate.

Maxine Sutton

Mustard, mixed-media textile by Maxine Sutton.

Maxine is a textile artist who designs and makes handmade interior products, based in Margate, Kent, England. She trained in fine art and was influenced by American and British abstraction. She comments: '*I love the idea of the workshop household and believe that the handmade object creates layers of significance and forms a part of personal and family narratives, making links and connections through generations. My practice rests on a strong belief in the importance of our connection to materials... Using hand-making techniques such as screen printing, Irish machine and hand embroidery with other traditional needlework processes, I aim to create accessible artworks and functional objects in which the tangible material qualities of the work will communicate on many levels. I continue to explore the interplay between printed and embroidered textures, colour, mark, drawn and stitched lines. I often play with imagery and ideas springing from our relationship with familiar domestic objects and environments, everyday pastimes and the meaning of "home" and home-making activities. Abstracted and illustrative forms are hand drawn, paper cut, found or sometimes photographic. Screen-printed surfaces are layered and collaged with appliquéd and needle-punched techniques, embroidered lines and densely embroidered areas create further layers, detail and texture.*'

Nancy Nicholson

I'm drawn to Nancy's intricately designed work as she uses plants, flowers and birds in many of her pieces. Nancy trained in fine art textiles at the Royal College of Art in London and her recent work uses her own designs as well as taking inspiration from her late mother Joan Nicholson's work, produced in the 1960s and 1970s. Nancy says: *'My work stems from a love instilled in me from my mother of the ultimate pleasure of making something slowly and beautifully by hand. I believe we want to slow down from our quick-fix, quick-thrill, immediate-satisfaction outlook these days. We are learning it is very pleasurable to spend some time over what we do and gain an enjoyment which would otherwise be missed... It takes time and patience to do something well.'*

Embroidered bird design by Nancy Nicholson.

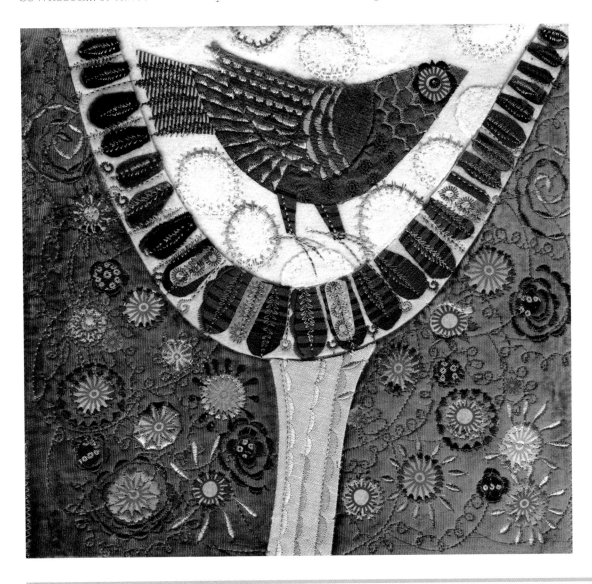

Floral collage –
'Vintage Flower Garden' workshops

I've enjoyed teaching at the Fibreworks in Chipping Norton, in Oxfordshire, England. It is a small and vibrant shop with workshop studio above it. It is a hub in the village and they run a Fibre Festival each summer there. I have organised several workshops and a favourite has been a 'Vintage Flower Garden' theme. We are able to dip into a lovely collection of floral fabrics at the studio, but I always encourage students to bring in a good selection of their own. Previously embroidered pieces of work, such as vintage teacloths, hankies, napkins and tablecloths, can provide excellent backgrounds for working on. We start with a simple outline drawing, to identify key areas and the composition of the piece. Students then choose a background fabric and start to cut out floral elements from their chosen fabrics, Using a combination of lace, floral and translucent fabrics, they are then able to layer them onto the background. When these are bonded to the background using iron-on bonding fabric, the students can concentrate on the other elements of the image. A house, a tree or plants can provide a focal point for the work. The example shown here demonstrates the type of thing that can be achieved using this technique. The final stage is to embellish the piece using buttons, ribbons and hand stitching.

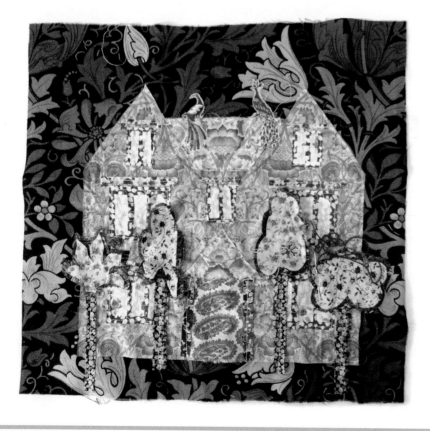

Lucy Shaw

Lucy has produced a lovely house collage, made from a long-treasured collection of Liberty printed fabric. Using this as her background range enabled her to make connections between different colours and prints. I was delighted to see the result with her delicate hand stitching and embellishing.

House collage by Lucy Shaw, made using Liberty fabric.

Selection of vintage
embroidery samples
from the author's
collection.

Folk art

The term 'folk art' is used to cover a wide range of styles from all over the world. It usually embraces bold images of familiar objects in bright colours that lift the spirits. Flowers, birds and plants are a recurring theme. The simple motifs, often combined with decorative elements, are easy to work with, and pieces are as fun to work as they are to view.

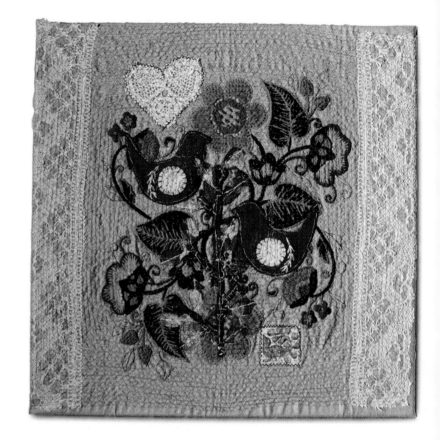

Folk, mixed-media textile by Anne Kelly.

Stencils, pattern and print

Looking at common garden plants and birds can be a useful place to find motifs and inspiration. Use your motifs to make prints, which can add depth and texture to your work and are a good way of breaking up the surface of your composition.

Choose a few interestingly shaped plants or animals, ensuring that they have a strong linear structure. These will be easier to draw and separate when designing your stencils. Birds and insects are also good choices.

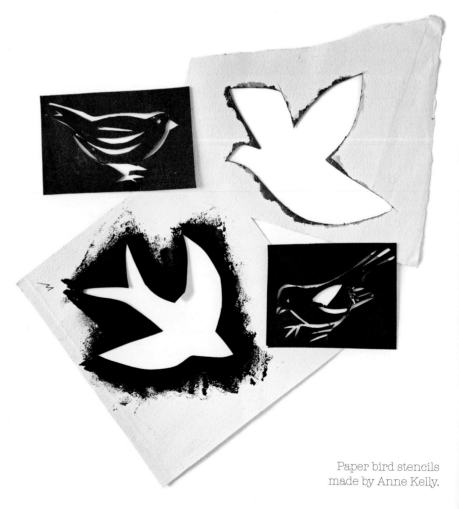

Paper bird stencils made by Anne Kelly.

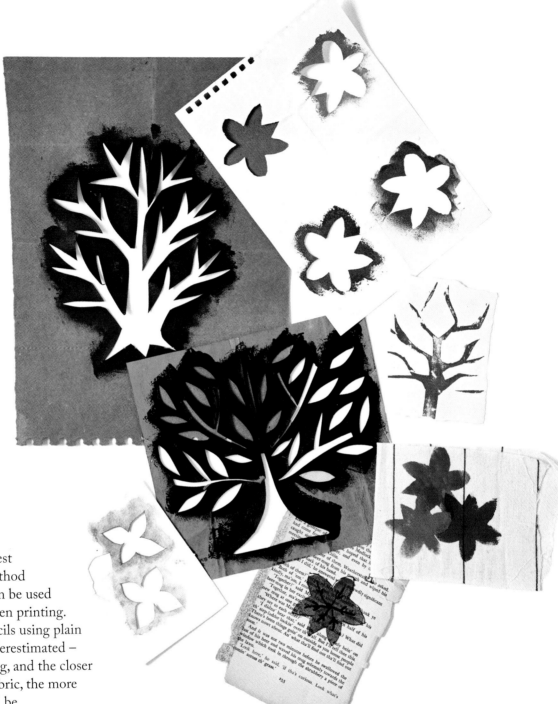

Stencils are the simplest
and most versatile method
of printing, as they can be used
for hand and also screen printing.
The durability of stencils using plain
cartridge paper is underestimated –
they can be very strong, and the closer
the stencil is to the fabric, the more
accurate the print will be.
This is the method:

1 Start with an image of a flower or tree that
you would like to use. I chose a Shaker
inspired motif of a tree (centre), and drew it
onto the paper.

2 Using a sharp scalpel and cutting board,
cut out the shapes of your design.

3 Position your stencil over the fabric you
have chosen to print on. Use masking tape
if you wish to secure the stencil. Using fabric
or acrylic paint and a small sponge, dab (do
not paint) the colour through the holes in
the image. Leave to dry.

4 When it is dry, you can iron the stencil
between clean paper and reuse it – the
paint left on will only make it stronger.

This stencil was used in my commissioned
piece *William Morris Trees* (see pages 28–29).

Indian block prints

On the *William Morris Trees* commission (see pages 28–29), I also used carved wooden printing blocks. These blocks are widely available and are useful for creating motifs and backgrounds in your work. Particularly effective over already printed and dyed fabrics, they can add colour and texture to mixed-media pieces. For the clearest, sharpest prints, place a padded cloth or towel under your printing surface. Use a sponge to apply your chosen paint to the block then press down with a slight rocking motion onto your fabric and remove the block.

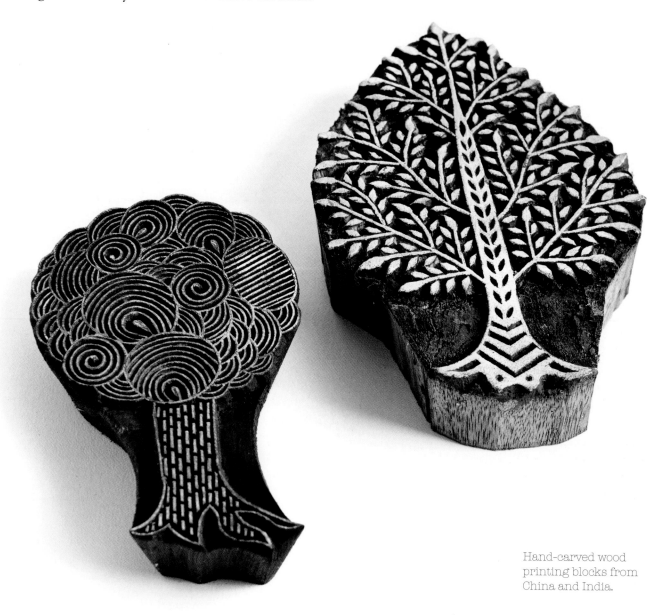

Hand-carved wood printing blocks from China and India.

Carolyn Forster

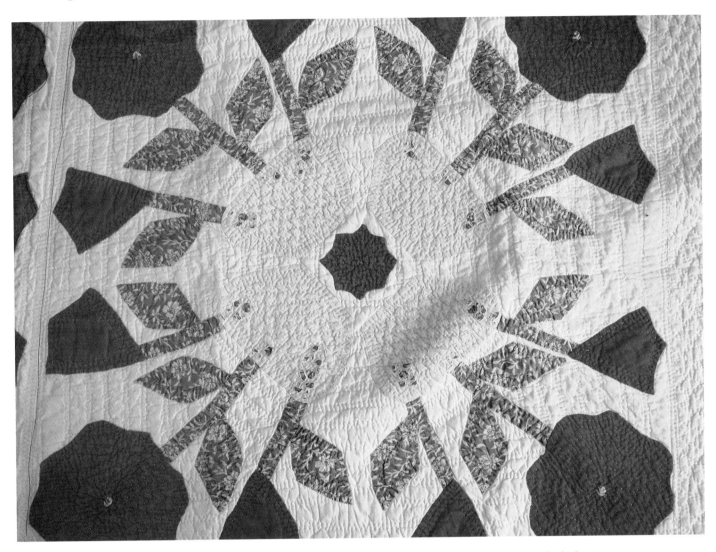

A hand and machine-stitched quilt provided inspiration for Carolyn Forster's *Antique Flowerpot Quilt* design.

Carolyn is a British quilter and writer, well known for her books on the subject. She describes her inspiration and the technique that she used for her *Antique Flowerpot Quilt*, adapting her design from an antique quilt (above) seen at an exhibition: '*The quilt that most attracted me was the one I named "the flower pot quilt". Ironically the faded, threadbare pots could hardly be seen from a distance. Despite the strength and vibrancy of the quilt it was its worn-out and faded quality, and also the softness created through years of use and laundering, that appealed to me. When I came to making my own version I chose to try and reflect that in choosing a very soft palette of fabrics, so that you have to really look at the quilt. I have joined some of the small pieces together to create fabric large enough to cut the bold shapes from. I selected various different background fabric squares for the appliqué to add some interest and help make the placement of these background fabrics interesting and less predictable. Another point that attracted me was that although all of the elements of the design are big and bold, the flower centres themselves are tiny. The maker used reverse appliqué to cut through the red of the flowers and insert a small piece of the turquoise for the centres. I chose to use a method of freezer-paper appliqué to make my top, although the large simple shapes could easily be sewn using needle turn. The quilt is very densely and finely quilted with a variety of designs even over the appliqué pieces. I am hoping I have managed to create that warmth and softness from the outset without having to wait a hundred years first.*'

Dyeing with plants

At Sussex Prairie Garden in southern England, the owners have encouraged local members of the Sussex Guild of Weavers to use the plants from the garden to make dyes to dye their wool with for spinning. When I was artist-in-residence, they used French marigolds. The vibrant and bright colour stood out when dried out and spun.

Ditchling Museum of Art and Craft

Ditchling Museum in Sussex, England describes itself as follows: *'The museum holds an internationally important collection of work by the artists and craftspeople who were drawn to the village. Being able to see special objects and works of art and craft in the village where they were made is a rare opportunity. It offers a unique way to consider how the objects were made and who they were made for. The impact of the many artists and craftspeople who came to live and work in Ditchling from the beginning of the twentieth century onwards established this village as one of the most important places for the visual arts and crafts in Britain.'*

Part of their collection contains work from the weaver Ethel Mairet. The museum also has links to the local Plumpton College and offers workshops in natural dyeing. They have started to grow a garden for natural dyes and will be adding to it as the project progresses.

Dyer Deborah Barker who attended a workshop there said: *'I saw that Ditchling Museum was offering a hedgerow dye workshop run by dyer and weaver Jenny KilBride… Jenny is the daughter of Valentine KilBride who worked as a weaver and dyer in Ethel Mairet's dye workshop in Ditchling in the first half of the twentieth century.*

Eight of us gathered excitedly around the stoves as Jenny produced the dye materials, which included rowanberries, blackberries, golden rod and dahlia flowers. It had been a grey autumn day but as we took dyed skeins of wool out into the museum courtyard to dry on the chestnut pale fencing the sky brightened and we were rewarded with the picture of the rich luminescence of the plant-dyed wool in the late autumn sunlight.'

Above left: Hand-dyed French marigold wool, dyed and spun by the Sussex Guild of Weavers at Sussex Prairie Garden.

Above right: Deborah Barker's hedgerow dyeing samples.

Above: Ditchling
Museum garden,
showing plants grown
for dyeing workshops.

'Dyeing is an art; the moment science dominates
it, it is an art no longer, and the craftsman must
go back to the time before science touched it and,
and begin all over again.'
Ethel Mairet, A Book on Vegetable Dyes *(1916)*

Supporting Statements

I was delighted to be involved with this project, in conjunction with Nell Mellerick, the artist-in-residence at Hospice in the Weald in Pembury, Kent, England. The piece consisted of three long textile hangings, which were hung from ceiling to floor.

This collaboration of artwork was made especially for the Tenth Palliative Care Congress in Harrogate and exhibited there. Every panel was made up from individual patients' art pieces. Each patient was encouraged to explore a self-portrait through a botanical representation of themselves and text about their favourite memory of it.

Nell said: *'This piece echoes the benefit of patients having access to the arts. It supports their creative needs, gives them a sense of purpose and boosts self-esteem when they have had so many losses through their disease. My role as Creative Artist provides an open session of craftwork, group art sessions, one-to-one sessions working on memory projects or exploring creative expression.'*

I have previously been involved in fundraising for the hospice and was looking forward to working on this group collaboration, *Supporting Statements*, with Nell and her patients. The theme reflects the care and encouragement that the hospice provides. The piece expresses reflective and hopeful qualities and provides a colourful backdrop for their self-portraits and journeys.

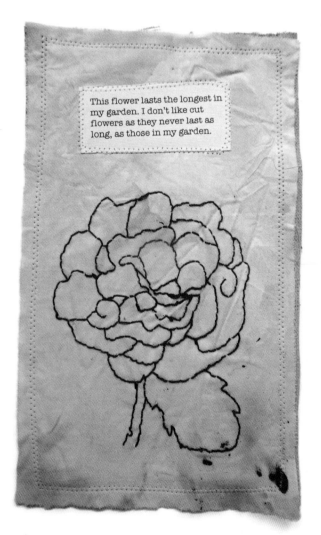

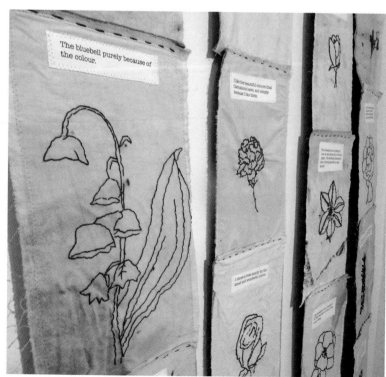

Detail from *Supporting Statements*, mixed-media textile hangings by Anne Kelly with Nell Mellerick and Hospice in the Weald.

Making a collage

Method for making a paper/fabric collage:

1. Start with a plain, lightweight cloth background. Choose a motif that is simple but striking to create your image.

2. Cut out pieces of fabric into the shapes that you are going to use for your imagery.

3. Make a mixture of 50 per cent PVA:50 per cent water to use as a binder to layer paper and fabric together. If using this method, your layers need to be thin, so that the glue dries quickly.

4. Brush the mixture over and under all of your layers – you can top it with white tissue paper if you like.

5. When it is dry, you can make tree shapes and leaves from fabric, which can be tacked in place on top.

By using simple shapes and colours I created a folk-art style image, which was overstitched with running stitch and embellished with buttons (shown below).

Tree collage, mixed-media textile embroidery by Anne Kelly.

Tree collage, mixed-media textile by Anne Kelly.

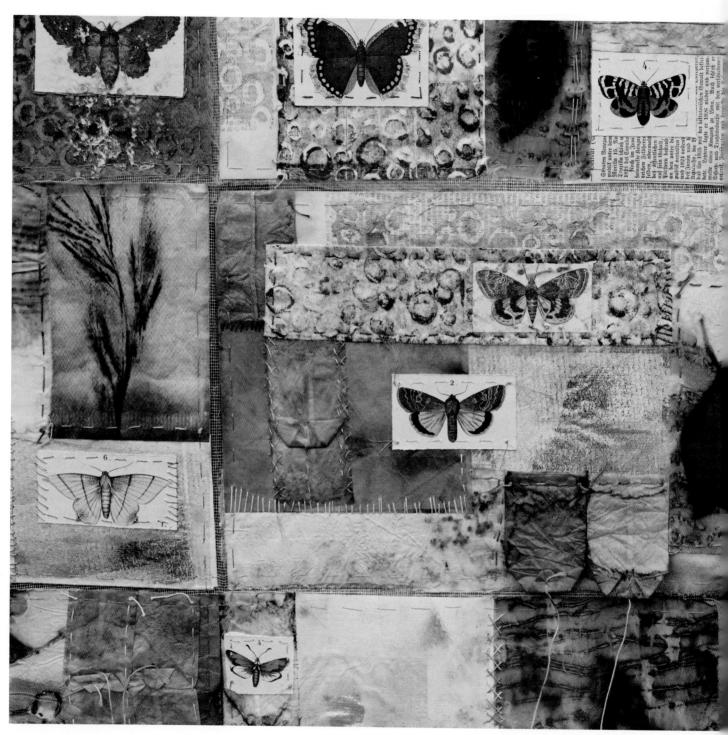

Detail of *Butterflies*,
mixed-media textile
by Judith Mundwiler.

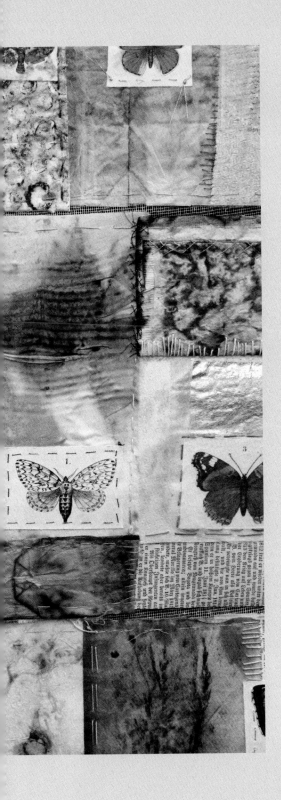

Taking flight

'I hope you love birds too...'
Emily Dickinson

Birds and insects

I am often asked 'Why birds?'. They are included in many of my pieces and also feature as subjects in their own right. The answer is simple. Birds are everywhere and co-exist with us in a rapidly changing world; they are symbols of the soul and of the imagination and at a deep level they seem to call to me. Insects, particularly butterflies, are favoured by artists for their symbolic value as well as for their beauty and charm. In this chapter birds and insects will be interpreted by a variety of artists and makers.

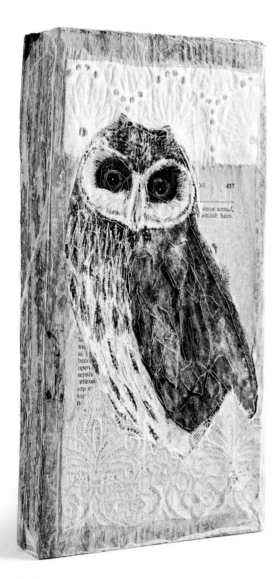

Owl, mixed-media textile mounted on wood by Anne Kelly.

Detail from *Birds* embroidery by Anne Kelly.

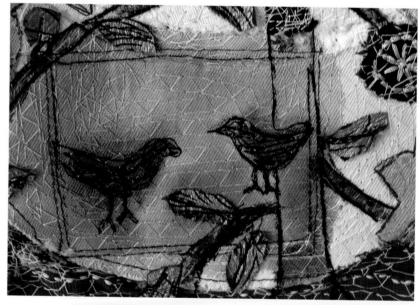

When I started participating in group shows and open studios, I made small objects to exhibit. I'm drawn to brooches and like wearing them so I made two kinds using insects for inspiration. I devised a way of trapping free-motion embroidered moths, stitched onto maps in between two layers of Perspex.

Detail from an untitled collage of mixed-media textile by Anne Kelly.

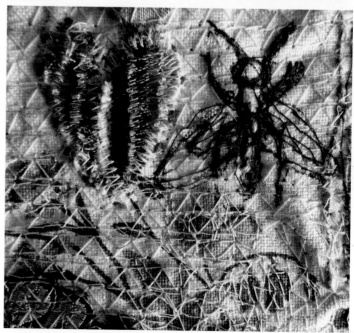

The Perspex had the function of magnifying the stitched moth, which was effective. My second brooch design involved recycling old thread spools, made from heavy card. I had a collection of these, some of which had writing on them. I glued them together to create a base on which to apply free-machine embroidered beetles, calling them *Thread Beetles*. I then applied a brooch pin to the back of each piece. Recently I've returned to this theme and made small 'nature block' brooches of moths and butterflies.

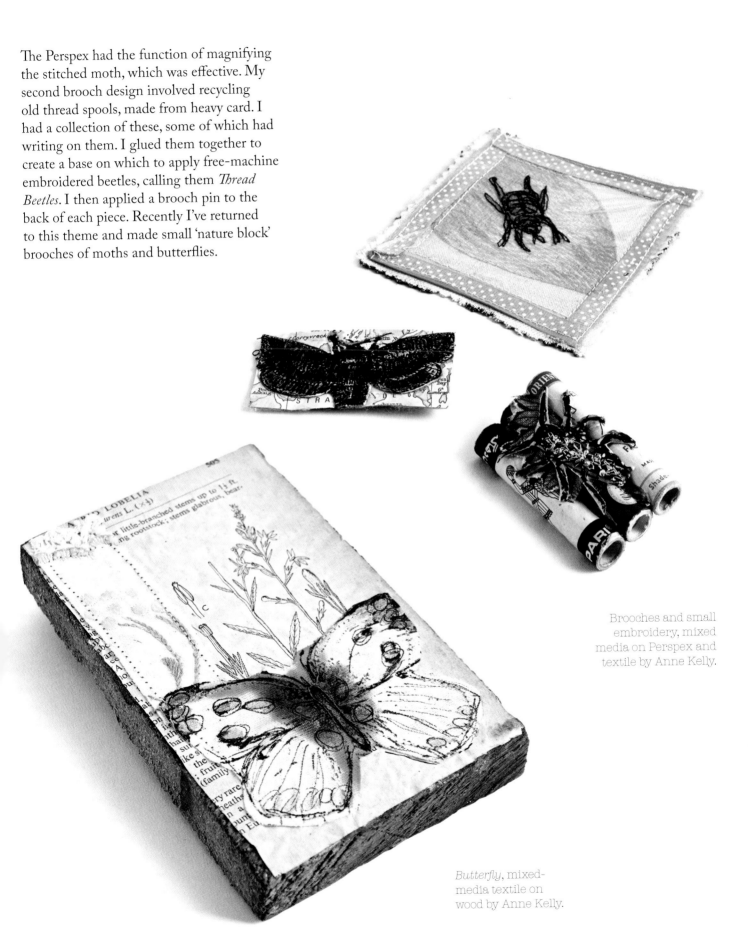

Brooches and small embroidery, mixed media on Perspex and textile by Anne Kelly.

Butterfly, mixed-media textile on wood by Anne Kelly.

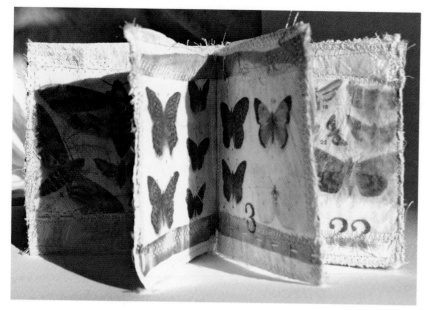

Butterfly Book,
mixed-media textile
by Anne Kelly.

Mini books

As well as making small objects, I have always liked putting
together small books, with images and themes that can be captured
in a hand-held format. I used a transfer method with T-shirt transfers
from vintage imagery (see page 36) to create the images on pages in
the book.

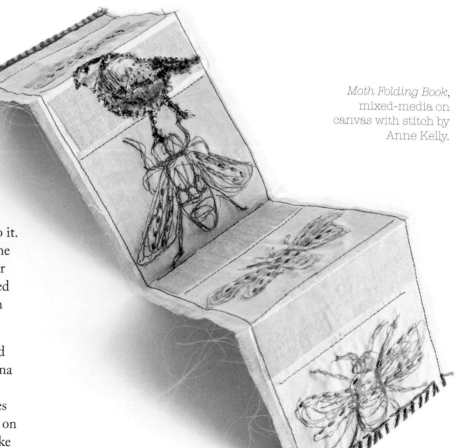

Moth Folding Book,
mixed-media on
canvas with stitch by
Anne Kelly.

I like to use calico or canvas for my mini
books because it has a good weighty feel to it.
In addition to using T-shirt transfers for the
pages I often use stamps, especially number
and alphabet stamps – the latter can be used
for adding words. I colour some pages with
dye and embellish with stitch.

My favourite book formats are the standard
book form (shown above) and the concertina
form as in the moth book (shown right).
For a standard book I simply bind the pages
together with a piece of canvas folded over on
the edge. Instructions for making a book like
the one shown on the right are on page 92.

An insect collaboration

Judith Mundwiler from Switzerland and Gabi Mett from Germany have worked together for many years. I was impressed by their collaborative work, which was displayed at the Festival of Quilts. They describe their collaboration and this series of work as follows: *'We have held exhibitions, written a book and designed courses together. Since our first exhibition, we have always strived to find linking points to connect our artistic personalities. We planned a presentation of our work at the Festival of Quilts in the UK (Birmingham) under the theme "Short Stories – Between the Lines", whilst keeping our individual styles and ideas. We kept in touch to discuss our work and plan further steps. One main point was that all the artwork had to be foldable. Our wish to exchange material as we did in our first joint exhibition was put into concrete terms during this process. We had bought two books from an antiquarian bookshop. One was a reference book on grasses and the other was a book on butterflies. These two books were dismantled and each of us got one half of each book to process further. The butterfly illustrations were especially inspiring.*

At this time, Gabi Mett was working on a series of artworks in which old sewing accessories were integrated. In this case it was paper bags that originally served as templates to tag linen in stores. In combination with the butterfly illustrations and the names of these insects, as well as thoughts on their disappearance at the present time, her work paid homage to these very special marvels. Judith Mundwiler has been working for some time with used teabags and eco-dying. In this work she combined these materials to draw attention to the beautiful butterfly drawings. She also references the extinction of insects with the title Are They Still Here? This artwork is sewn and embroidered by hand.'

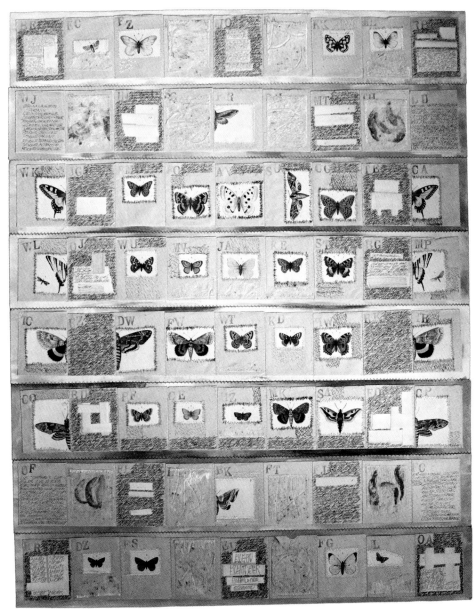

Are They Still Here?,
mixed-media textile
by Gabi Mett.

A buzz about bees

Bees are very much in the news worldwide, and our relationship to them is one of interdependence. When I was artist-in-residence at Sussex Prairies Garden, I decided to make a series of work looking at the different types of bees there are in British gardens. I started with an appliquéd and patched background, to which I added free-machined bees and a title for each type of bee (for example, garden, meadow and so on). The garden has an ongoing project with Sussex University using Warré hives, which give the bees a more natural home than the National hives more commonly used. A fascination with insects is also evident in many other contemporary artists' work.

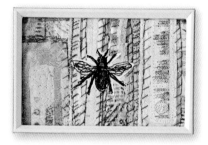
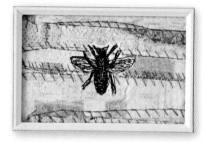
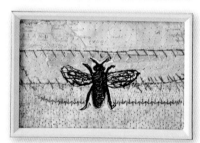

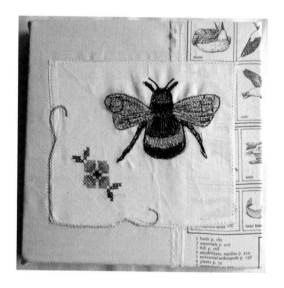

Three Bees, mounted mixed-media textiles by Anne Kelly.

Bee, embroidery on vintage table linen by Anne Kelly.

Lesley Coates

Lesley Coates is a talented student who enjoys working in a wide variety of media. Here she has drawn and coloured a moth design on calico and embroidered one version.

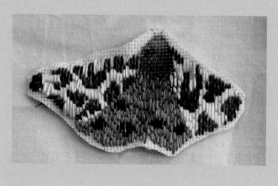

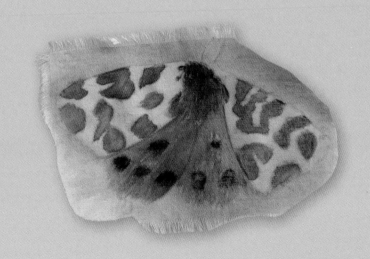

Moths by Lesley Coates.

Garden birds

After working with Anna drawing birds at her studio, I decided to create a series of mixed-media works incorporating paintings of garden birds. I started with a background made from pieces of fabric that reflected the garden, either printed or embroidered, and stitched them together. Over the base layer I incorporated my paintings on calico of garden birds. I like to use paint with a soft non-plastic finish, like good quality acrylics or casein tempera. At this stage, I also added small remnants of lace and fabric, to provide focal points for the work.

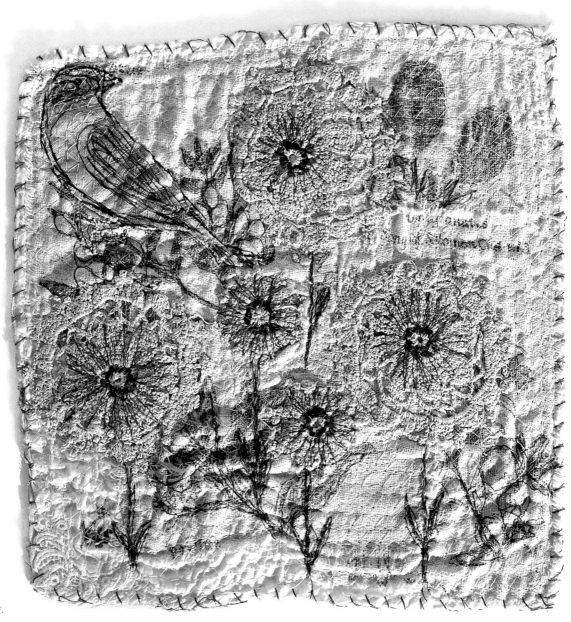

Bird Handkerchief series, mixed-media textile by Anne Kelly.

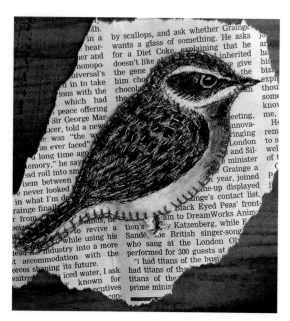

Bird, mixed media on
textile by Angela Kent.

Students' birds

I teach mixed-media courses as well as textiles and one of our projects
was to draw and design birds to fit into a Joseph Cornell-type
constructed box. One of my students, Angela Kent, decided to draw
and colour a bird on fabric, mounting it onto newspaper. She then
stitched around the edge with blanket stitch, embellishing it further.

Mixed-media collage
on paper by Anne
Kelly and *Bird*,
mixed-media textile
by Helen Ott.

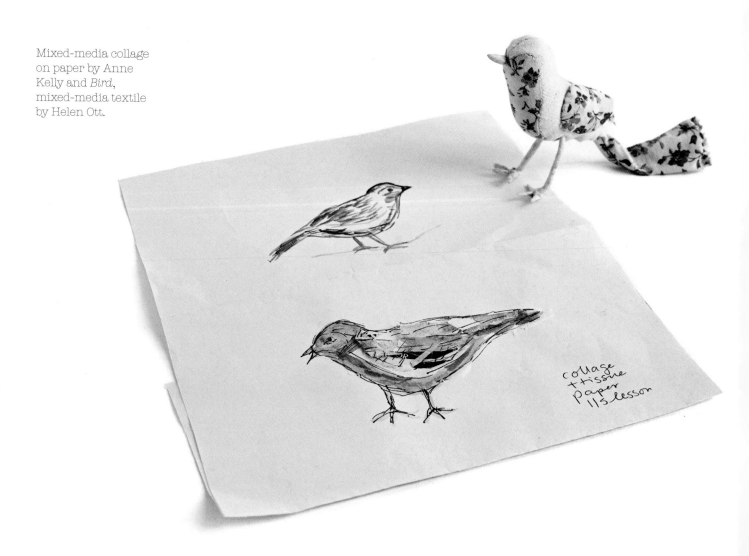

Nicola Jarvis

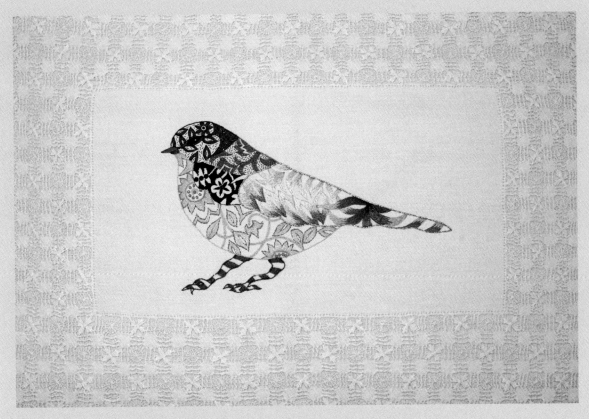

Bird, embroidered textile by Nicola Jarvis.

Nicola is an artist and senior tutor at the Royal School of Needlework in London. She has made a series of work inspired by William Morris, which was exhibited at the William Morris Gallery in London and toured William Morris houses around the UK.

Nicola says: *'When I was a child we lived on the edge of a town overlooking open fields and I would amuse myself in the long, rambling garden of my home. The changing colours and atmosphere of this place became a wondrous backdrop to days spent poking about in flower beds, peering into shrubs and trees to look at insects and spy on birds' nests. I was mesmerised by the myriad hues of plants and flowers, watching the light intensifying on their textures or casting silhouettes against the sky. This was where I developed a fascination and sensitivity for nature that continues to feed my practice today. I always explore initial ideas through drawing when beginning a design project or embarking on an artwork. Drawing is central to my practice and a new project will begin with selecting a natural form, for example, a flower for the compelling colour of its petals, some interestingly shaped leaves or the irresistible patterns of a bird. An endless stream of stimuli will attract my eye toward something, which is then clarified in the act of drawing when the eye, imagination and hand collaborate. In capturing and processing these visual and tactile qualities, I represent them in a way that exposes much potential for design. I am continually developing my personal culture of drawing and embroidery, and examine this through the design processes and aesthetics of specific artists and designers from various historic periods. I try to understand nature by examining it closely and then use my imagination to develop ideas.'*

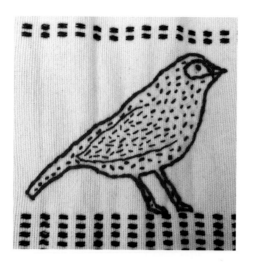

Embroidered birds

I enjoy working on vintage and reclaimed fabrics, so when I decided to create a small series of bird embroideries for a solo exhibition, I repurposed some table linen and old fabrics for the project. I made some simple drawings that I transferred to the fabric and then stitched along the outlines and added detailing where required. As you can see in the example shown left, I deliberately kept the informal, sketchy look of the drawings to maintain the lively, gleeful feeling of the originals. Sometimes artists can try too hard to create 'perfect' images and overwork them, taking all the life out of them in the process. Try not to worry about getting it right or wrong, just concentrate on expressing what you feel and what you want to convey.

Bird series, hand stitching on vintage textile by Anne Kelly.

Suzette Smart

Making birds in three dimensions can be challenging but an effective way of capturing their characteristics. Suzette is a textile artist and tutor who crafts beautiful machine-embroidered pieces and three-dimensional birds. She describes them as follows: *'Through the textures and patterns found in the stitch, each little bird reflects the landscape in which it travels. To complete its story, props such as stitched postcards and words are then added.'*

How to make a three-dimensional bird, by Suzette Smart:

1 With no set pattern, layer small pieces of scrim and voiles onto stiffened fabric and stitch down with free-machine embroidery. The stitched fabric should be eclectic with vermicelli, flowers and words. You will need to make a piece of embroidery around A4 in size.

2 Draw outlines for two wings, two sides and two gussets onto card and cut out. Move the templates around the embroidery to find the perfect pieces.

3 Position and stitch the wings and buttons for eyes onto the sides and add buttons or maybe sequins for the eyes. Then you can begin to hand stitch the pieces together, starting at the top of the bird.

4 For the legs and feet, you will need one length of wire. This is stitched securely into place through each side of the bottom seams. Now shape both ends of the wire into birds feet, add a little stuffing and finish stitching your seams together. Finally, hold the feet down with the palm of your hand and gently bend to find the bird's standing position.

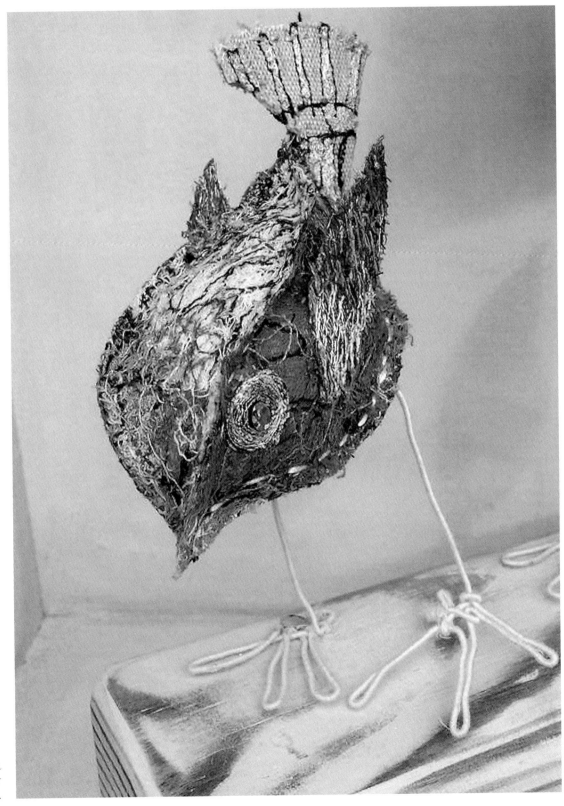

Mixed-media
embroidery bird by
Suzette Smart.

Catherine Frere-Smith

Catherine Bennett (designing under her maiden name Frere-Smith) is a textile designer and artist, designing printed textiles and embroidered sculptures inspired by her childhood upbringing in rural Kent, England. She is greatly inspired by nature and during her time studying at Chelsea College of Art in London it became the main focus of her work.

Mixed-media textile blue tit by Catherine Frere-Smith.

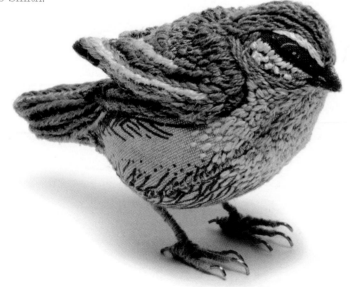

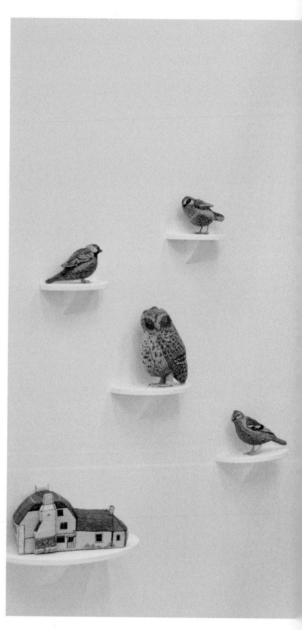

Catherine Frere-Smith's Final Collection BA exhibition, Chelsea College of Art.

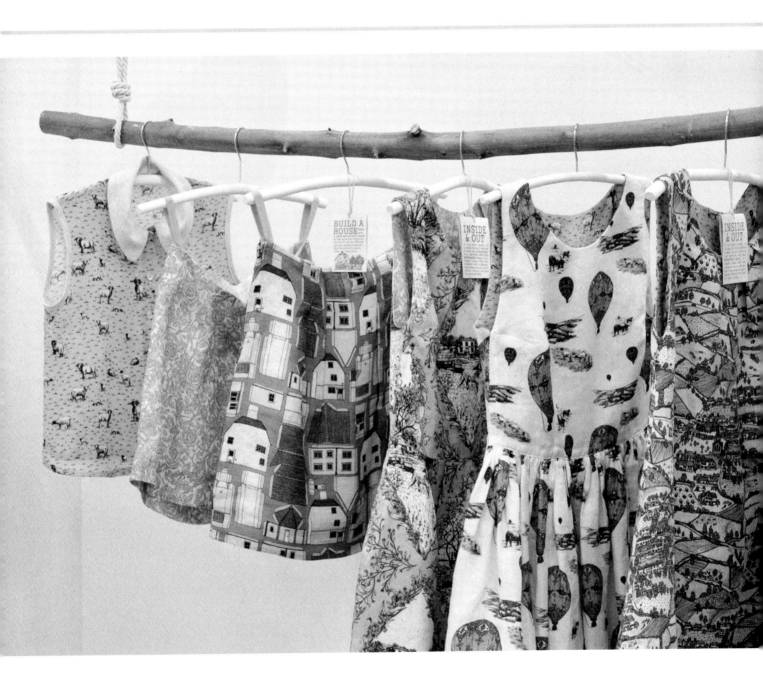

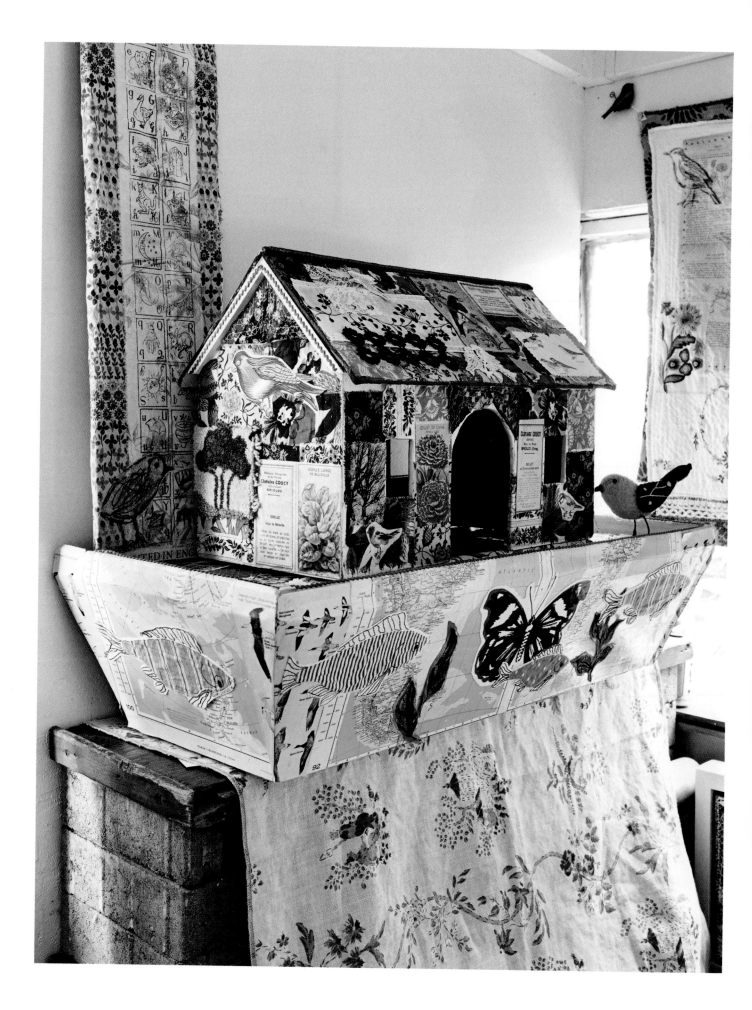

Paper mâché birds

These little birds were made as a contribution to my community installation piece *Sparrow Stories* by artist Jenifer Newson. They were added to the piece and pinned on the surface. They are beautifully hand painted and worked well with the textile background.

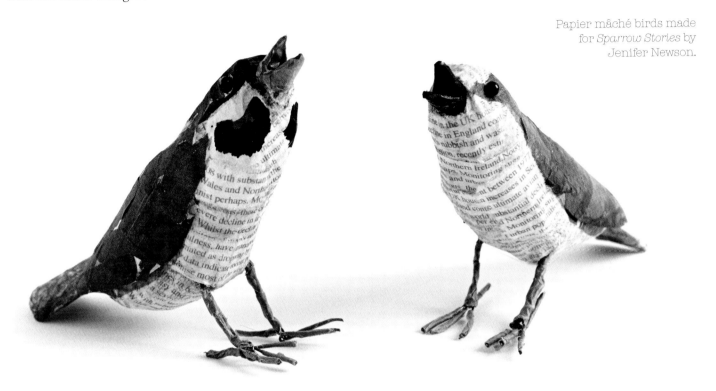

Papier mâché birds made for *Sparrow Stories* by Jenifer Newson.

An Ark for Birds and Moths

I had made some flat pieces combining collage and stitch for my nature blocks (see page 66), using recycled wood offcuts. I found an old handmade Noah's Ark in a local charity shop and was inspired to create *An Ark for Birds and Moths*.

It was a large piece and needed a lot of cleaning and preparation. When I had prepared the surface, I chose images and fragments of fabric with birds and moths to laminate onto the ark. I used some stitched pieces and printed panels to cover larger areas. As a finishing touch, I used lace and ribbon to edge and highlight aspects of the ark – including the windows.

An Ark for Birds and Moths, mixed media on wood by Anne Kelly.

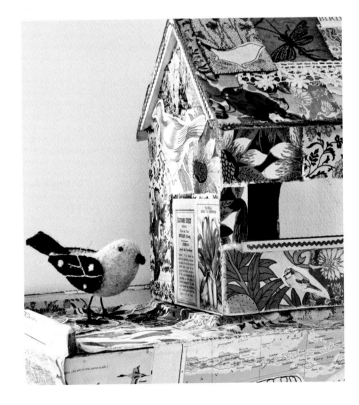

Alternative views

Woodland Walks backpack

I was given this damaged canvas rucksack and decided to rescue and embellish it with woodland scenes and images from a vintage woodland history book. I used the edges of an old table napkin, with lace and linen as part of the background. The heavily embroidered pieces have woodland animals on them, done with free-motion embroidery. It was first exhibited at the Prague Patchwork Meeting.

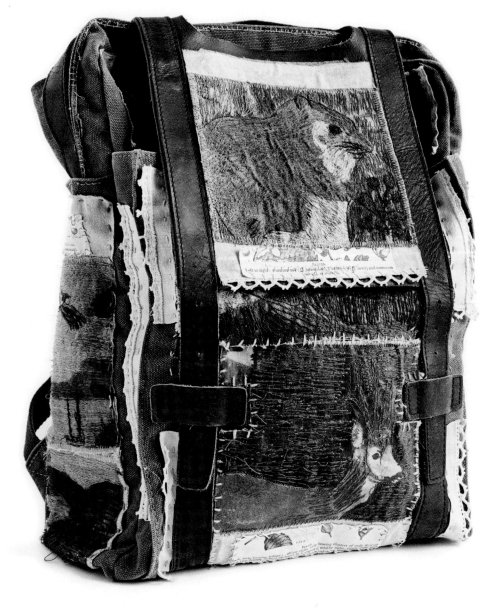

Woodland Walks backpack, mixed media on canvas by Anne Kelly.

Detail from *Woodland Walks* backpack, mixed media on canvas.

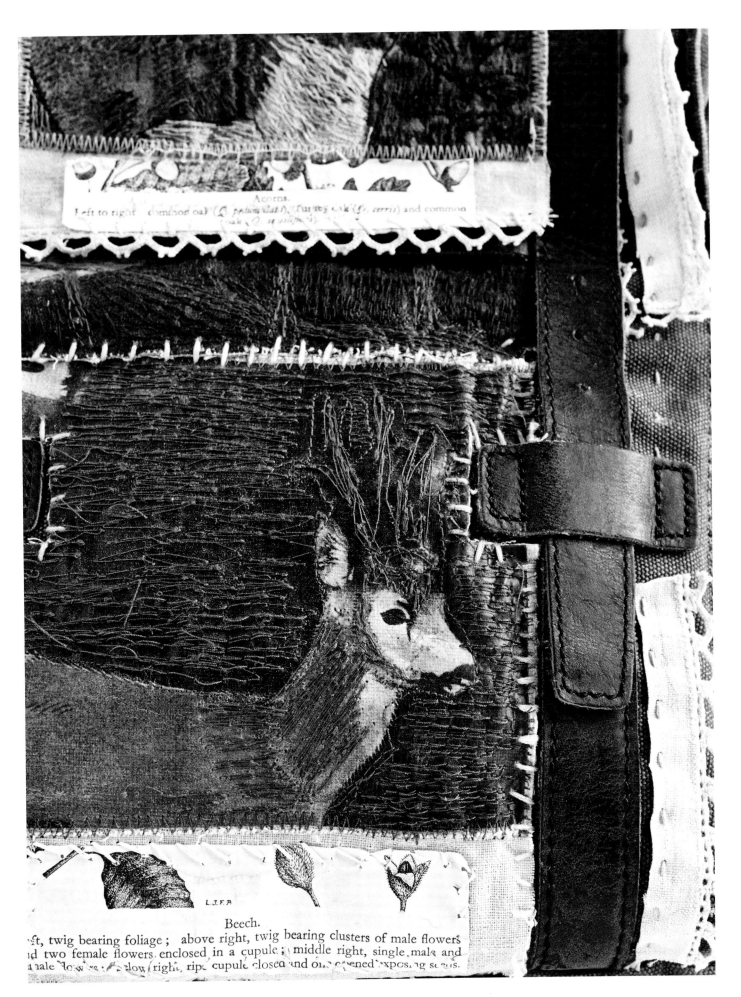

Acorns.
Left to right common oak (*Q. pedunculata*), Turkey oak (*Q. cerris*) and common oak (*Q. sessiliflora*).

Beech.
...ft, twig bearing foliage ; above right, twig bearing clusters of male flowers
...d two female flowers enclosed in a cupule ; middle right, single male and
...male flowers : below right, ripe cupule closed and one opened exposing seeds.

Leisa Rich

Leisa is a Canadian-born, American-based artist. She describes the technique behind her impressive wall installation *Mass Hysteria*:

'In 1971 my mother taught me to sew. One of our sessions covered "darning". Using a Bernina 807, she demonstrated how to drop the feed dogs, change the foot to a darning foot, and move the material around in various ways in order to repair a tear in a skirt, a hole in a sock, to fix anything that needed it. It didn't take me long to figure out that I could use this technique to "draw". I remember creating a little dog on a scrap of cotton. This kicked off my fascination with using a sewing machine to embroider, a technique that has since been coined as free-motion machine embroidery. Pretty much any sewing machine has this capability, although some do it more easily than others. In addition, there are now multitudes of papers, dissolvable glues, heat transfers and surfaces that can be stitched on, washed away, stitched over and layered, using decorative threads, embroidery cotton in the bobbin, elastics and more. The technique is now limitless!

Mass Hysteria is done on clear vinyl in similar free-motion machine embroidery fashion. Each bird attaches to the wall using small straight pins and can be formed into a myriad of configurations. I still use that same Bernina 807 that I first learned on back in 1971!

Mass Hysteria is my personal reflection on the challenge of watching my mother face dementia. These thoughts became birds ... careening wildly in Hitchcockian attack mode, or tethered like kites so they won't get away.'

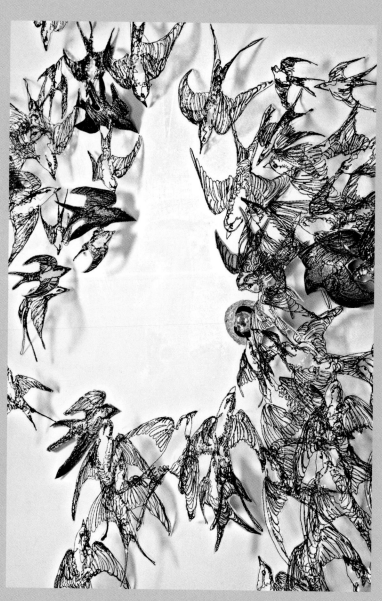

Mass Hysteria, mixed-media textile by Leisa Rich.

Lesley Patterson-Marx

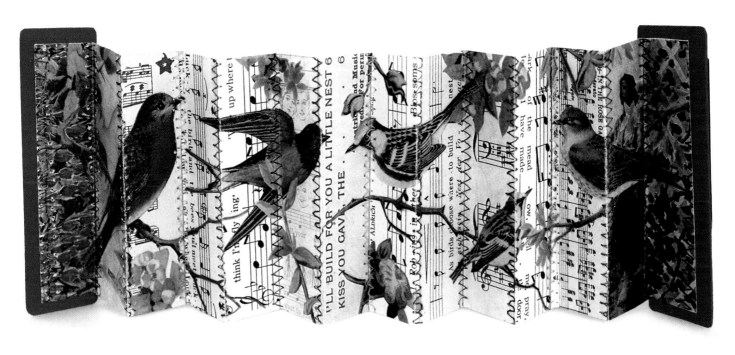

Songbird Harmonica Book, a limited-edition reproduction
of the original book by Lesley Patterson-Marx.

Lesley produces a diverse range of work in many media. I was drawn to her use of found objects and stitch, evident in this *Songbird Harmonica Book*: '*I was looking at an old harmonica and realised that, with its two cover plates, this musical instrument had the potential to become a book. The plates weren't too interesting, though, so I went in search of a unique harmonica and found the perfect one: an antique instrument called The Songbird. The name itself inspired the content of the piece. I created the pages, which fold up like an accordion between the two covers, from antique sheet music. To make the pages more durable, I backed them with a porous fabric called tarlatan, which I frequently use in printmaking. I collaged images of songbirds on top of the sheet music and sewed the pages together. The result is an object that looks like a harmonica at first glance, but then opens to reveal an unexpected surprise of colourful songbirds.*'

Working from life

Booth Museum of Natural History, Brighton, England

Many cities and towns around the world contain natural-history museums, and these are a wonderful resource for textile artists working on themes from nature. The Booth Museum in Brighton, England specialises in birds and butterflies so it is of special interest to me. As the description on the website says: *'The Booth Museum was founded in 1874 by naturalist and collector Edward Thomas Booth. The Victorians were passionate about natural history and Edward Booth's particular interest was ornithology, the study of birds. During his lifetime he collected a huge variety of stuffed British birds and was a pioneer of the environmental type of display called "diorama", displaying birds in their natural habitat. It was this collection of over 300 cases (with the proviso that the dioramas should not altered) that launched the opening of the museum under Brighton civic ownership in 1891. In 1971 the Booth became a Museum of Natural History.'*

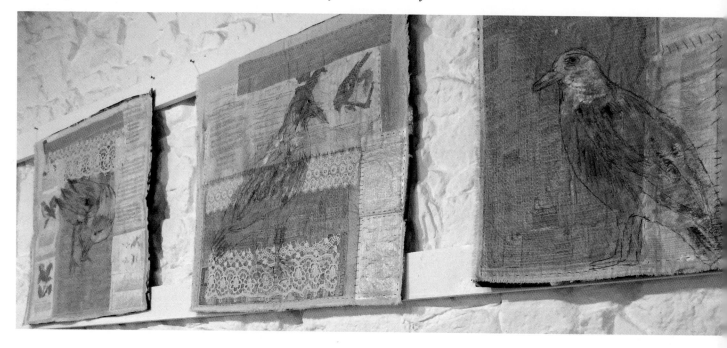

I was interested in making some studies of seagulls and headed for this museum as it is possible to get very close to the dioramas and the birds inside them. I drew them onto brown paper with ink (as shown right), and then transferred the drawings onto a mixed-media collage of fabric and paper that had been dyed and laminated onto canvas. I then stitched the gulls with free-motion stitching.

The series was exhibited at the Harbour Gallery on the island of Jersey as part of a nature-themed exhibition. I also gave a series of workshops there based on seabirds, where Jenny Mahy, one of the students, created the piece shown opposite, above.

Gulls series in exhibition at Harbour Gallery, Jersey, mixed media on canvas by Anne Kelly.

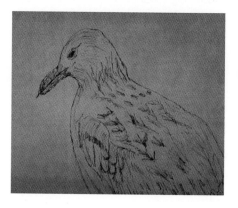

Gull drawing by Anne Kelly.

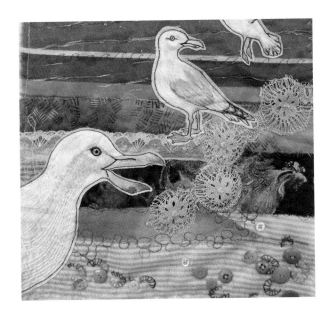

Seagulls by Jenny Mahy, from the course at Harbour Gallery, Jersey.

Lindsay Taylor

Lindsay is a textile artist and tutor based on the Isle of Wight, England. She was commissioned to make a piece of art inspired by one of the Dutch masters hanging in the Wallace Collection in London. Instantly she was drawn to a 17th-century painting by Jan Weenix, *Flowers on a Fountain with a Peacock*. Her challenge was the peacock, with all his splendid feathers.

She says: '*Like any creative venture that takes the natural world as its cue, my work is ever-evolving. My interest in three-dimensional forms has prompted me to extend my skills and seek out and explore new techniques and materials.*

Taking the abundant beauty and untamed, intricate shapes of the natural world as my inspiration, I work predominantly in three dimensions, weaving and winding hand-dyed natural fabrics into organic forms. My studio is located at the edge of a large forest on the Isle of Wight, an ideal environment for any artist fascinated by the native plants and flora that inhabit Britain's woodland and rural landscapes. Here my textile work takes shape. To work these transformations I use a variety of techniques. These include: free-hand machine embroidery, traditional hand embroidery, painting, dyeing, quilting, moulding, felting, sculpting, beading, trapunto, wiring and appliqué.

My materials are chosen carefully for their texture, credibility and aesthetic appeal.'

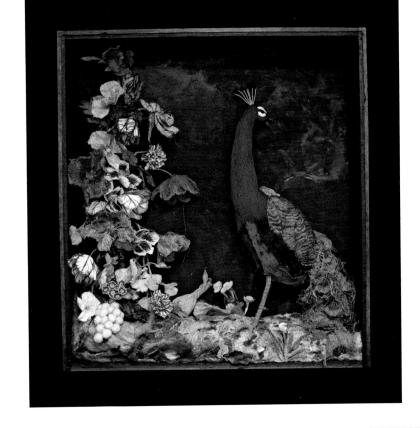

Peacock, mixed-media embroidery by Lindsay Taylor.

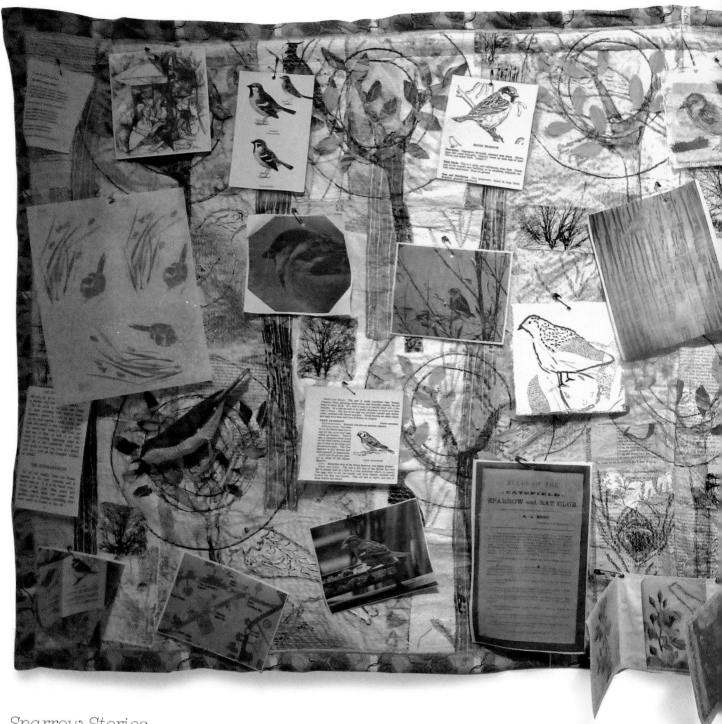

Sparrow Stories

For a recent solo show, I exhibited a series of new autobiographical pieces (see the *Aprons* series, pages 114–115) and wanted to include a community collaboration so I decided to make a piece that would help to raise funds for the RSPB. I was made aware of the worldwide decline of the sparrow population, which disturbed me as I had always taken these small birds for granted. I made a densely embroidered background of trees and birds, and invited contributors to donate stories, pictures, poems and even three-dimensional models of sparrows. The response was tremendous and we even arranged to have a sparrow soundtrack playing at the exhibition opening. A representative from the RSPB was present and helped with the fundraising and providing information on the organisation and their projects. During the exhibition, I held a workshop with a community group who made stitched pieces to contribute to the piece. I was delighted to be invited to take the piece to the RSPB education centre on Hampstead Heath near London where it was displayed for eight months.

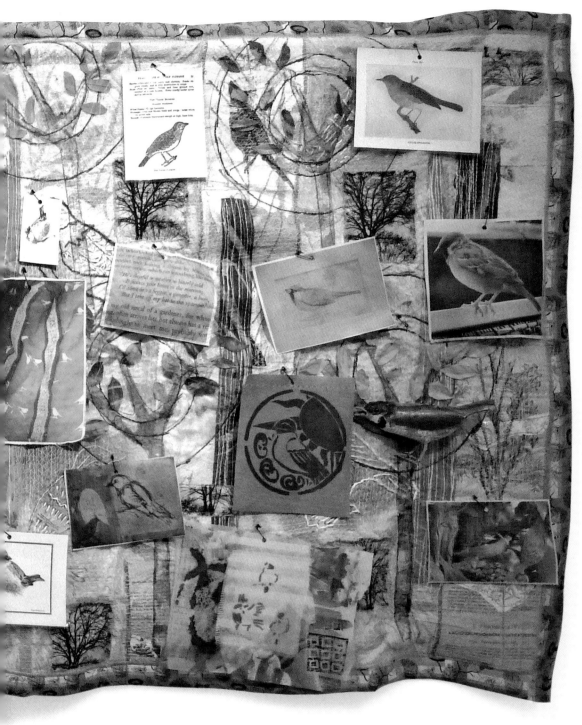

Sparrow Stories
by Anne Kelly,
a community
collaborative piece,
embroidered
background
with mixed-media
pieces pinned to it.

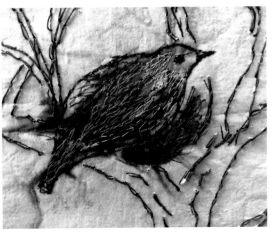

Sparrow,
mixed-media
embroidery on
paper by Anne Kelly.

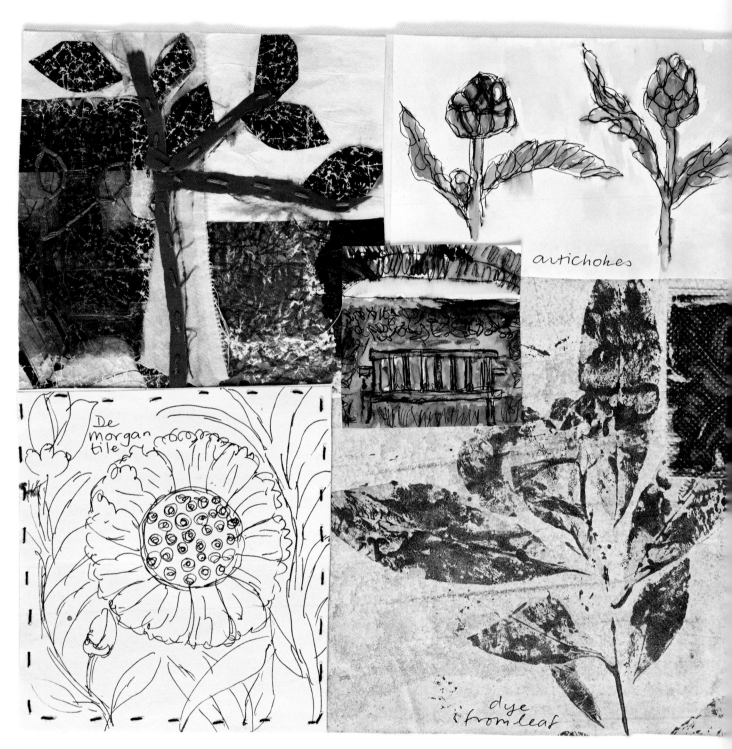

artichokes

De Morgan tile

dye from leaf

Pages from the author's sketchbook.

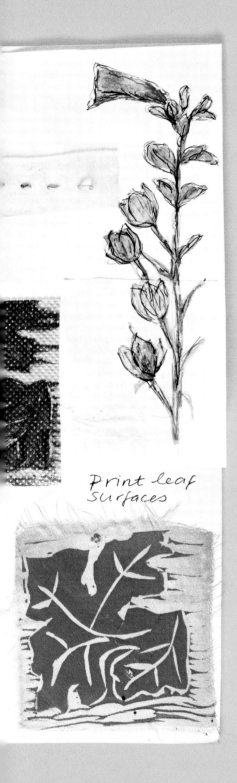

Print leaf
surfaces

Working with green spaces

'So still were the big woods
where I sat, sound might
not yet have been born.'

Emily Carr

View into the garden at Sussex Prairie Garden.

The Natural History of the Garden at Sussex Prairie Garden

I was artist-in-residence at Sussex Prairie Garden, an RHS partnered garden nestled in the South Downs near Henfield in West Sussex, England. The McBride family had transformed their farm into a wild-planted prairie space in keeping with the design ideals of internationally renowned garden designer Piet Oudolf, whom they had worked with. The garden specialises in the planting of sweeps of perennials and exhibits the work of artists, sculptors and craftspeople. I wanted to create an installation that would engage with and inspire the visiting public. I decided to use my love of folk art and created templates of birdhouses, trees and plants to make hardboard shapes, which were then covered with recycled fabric.

I made bunting to go across the top of the wall with the title of the piece *The Natural History of the Garden*. I left a space in the centre of the installation for a set of 'washing lines' on which to peg contributions to the wall display. I had asked students and the public via social media to send me JPEGs of plants, animals, poems, photographs and any references to the garden. There were some wonderful responses and the installation grew throughout my residency.

Detail of wall installation and bunting by Anne Kelly at Sussex Prairie Garden.

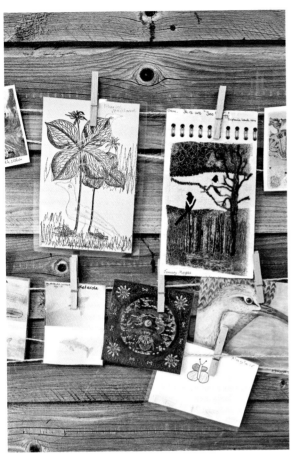

We allocated a weekend in the summer to be a fundraising event for the RSPB and asked their community fundraising team, whom I had worked with previously, to help to organise a series of activities including a nature trail for visitors. As part of the weekend, I conducted workshops with children. I also taught a series of adult courses at the garden, exploring different aspects of the space and referencing plants in different formats. I kept a sketchbook of my time at the garden and set myself the challenge of making a drawing every time I visited it. I also organised a system whereby visitors to the garden could contribute to the wall piece by helping themselves to images, fabric and embroidery cotton for stitching. They were able to sit and stitch and also take the work away to finish when they wanted to.

Community collaboration installation (below) and detail (left) at Sussex Prairie Garden.

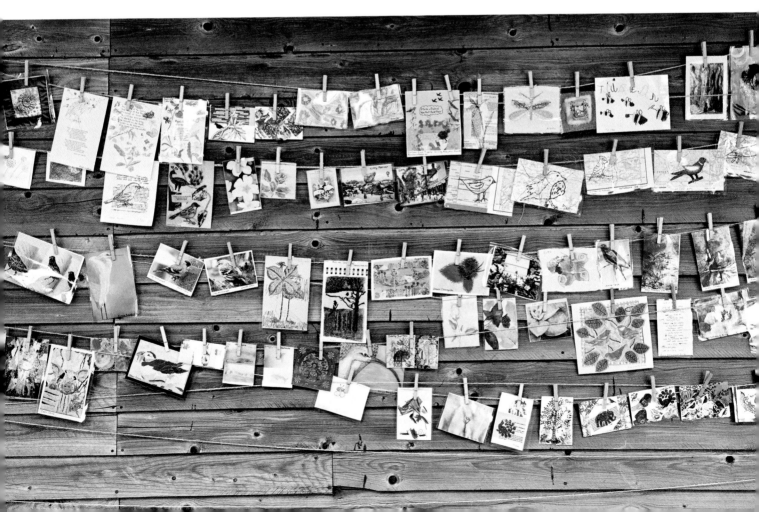

Covered Wagon studio

I was keen to establish a workspace and studio during my residency at Sussex Prairie Garden. I wanted it to be a welcoming space that guests to the garden would be able to 'dip into' when visiting. I collaborated with the owners of the garden who had found a 'wagon'-shaped growing frame, which I could use as the main structure.

Covered Wagon studio, Sussex Prairie Garden.

I had some help from the volunteers at the garden to reinforce the structure with bamboo poles and string as poles to go across the wagon. These were later to be used for hanging drying fabric.

I placed some work tables under and near the structure. I then made a large cover for the whole piece out of recycled embroidered tablecloths and teacloths. This would eventually be disassembled into separate pieces that I used in *Wildflower Teacloth Sketchbook* (see page 40). The studio was used throughout the season and acted as a good backdrop for displaying work.

One of the workshops I gave at the garden concentrated on folding books (see instructions on page 92).

Wallhanging, Sussex Prairie Garden.

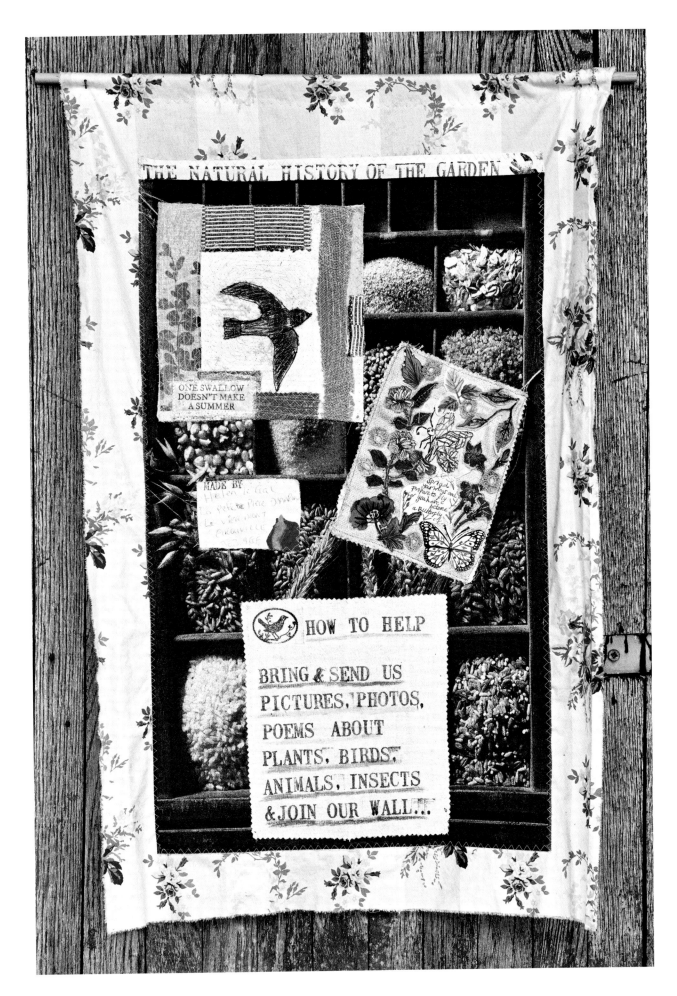

Making a folding book

Here are some simple instructions for making a folded book:

1 First, select the papers and fabric you would like to use for your book, assembling them in a long rectangular shape that will later be folded.

2 Choose a strong but lightweight fabric (calico or light canvas is ideal) and bond the cut-out paper pieces with the fabric together using a diluted 2:1 mixture of PVA glue. Hanging your rectangular piece to dry will ensure it doesn't stick to surfaces. You can continue to use this mixture to add further images, drawings and thin fabric scraps.

3 When your piece is completely dry, you can iron it into folded sections. I've chosen leaves, using real, printed and drawn leaves alongside leaf skeletons as my subject. I've used a combination of machine and hand stitching to embellish the piece, and I've also added some words to focus on and make the design more interesting.

This piece was auctioned by Workshop on the Web founder Maggie Grey to support the Teenage Cancer Trust.

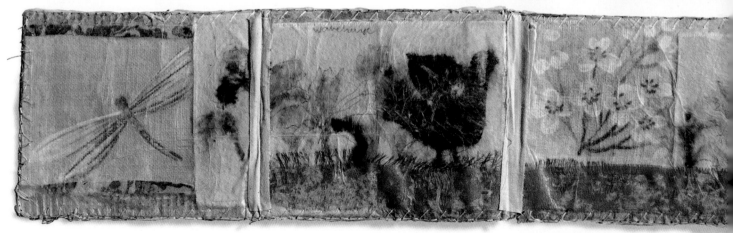

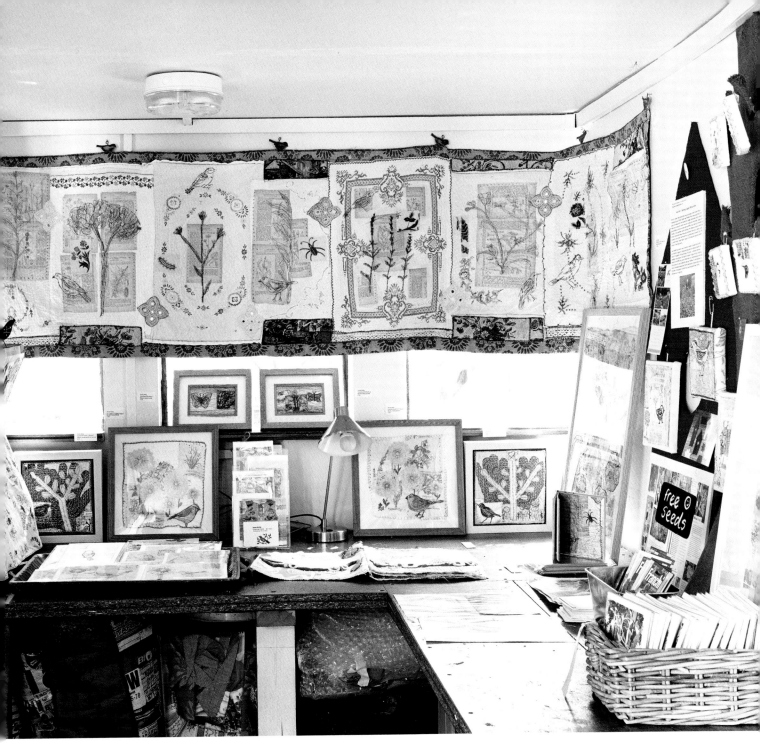

Shed Studio during the
Cross-Pollination at the
Chelsea Fringe event
(see page 94).

Wakehurst Place book,
mixed-media textile
on card by Anne Kelly.

Cross-Pollination

Following on from my residency, I was keen to establish links
with artists-in-residence at other gardens. Louise Pettifer was
artist-in-residence at Sissinghurst Castle garden in Kent, England.
She trained as a textile designer and produces layered plant collages,
using a technique similar to the method I use for making hand-cut
stencils for printing (see page 37). She draws the plants and cuts
them out of thin card/paper. Sections of the plants are layered over
each other and the whole image is then added to a monoprinted
background. She reproduces these originals as prints, which can
then be transferred onto a range of surfaces, including textiles.

*Cottage Garden,
September*, monoprint
and cut paper by
Louise Pettifer.

Rosie MacCurrach

Laurel and Pear Tree, etching on
paper by Rosie MacCurrach.

Rosie trained as a textile designer – her drawings embrace this and are multi-tonal and layered.
They perfectly reflect the changing seasons and activities at the famous garden of Great Dexter in
East Sussex, England, and are reminiscent of the great illustrators of the 1930s and 1940s such as
Edward Ardizzone and Eric Ravilious. Capturing atmosphere and light in her work and creating small
vignettes of her surroundings, Rosie's works can tell us a lot about working in garden surroundings.

In early 2015 we exhibited together at the Crowborough Centre in East Sussex, England, and provided
statements about our residencies as well as examples of work produced there. We also participated
in the 2015 Chelsea Fringe, which is a charity running garden-themed events in areas around the
Chelsea Flower Show in London.

A natural place

Green spaces inspire and working from nature first hand is the best way to learn.

Royal School of Needlework

The Royal School of Needlework (RSN) is a forward-looking charity dedicated to teaching, practising and promoting the art of hand embroidery. It runs courses in hand embroidery for all levels from beginner to degree programmes in all techniques. It has an Embroidery Studio for work on both the conservation and restoration of historical textiles and for creating new commissions.

Blackwork thistle by Royal School of Needlework Certificate student Yuliya Klem.

Silk shaded floral bouquet, English twentieth century, Royal School of Needlework Collection.

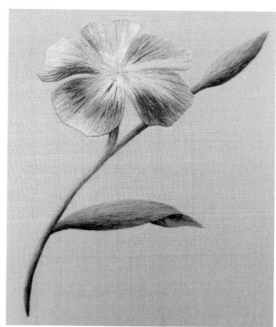

Silk shaded *Linum perenne* (perennial or blue flax) by Royal School of Needlework Certificate student Kaoru Ozaki.

RSN says of the Inspired by the Garden (2015) exhibition: *'Almost since the start of embroidery, capturing flowers and the natural world has been an irresistible subject for stitch. Embroidery lends itself perfectly to capturing the textures, colours, shapes and movement of nature and on show were beautiful pieces of work including traditional floral interpretations and a host of more unusual embroidery subjects from vegetables and fruit to fungi.*

The exhibition featured historic work from the RSN collection together with current embroideries by RSN students and tutors – all inspired by the natural world using a wide variety of stitched techniques. Historical pieces date from the eighteenth century and the exhibition will come right up to date with pieces submitted in for the RSN Degree, Certificate and Diploma courses.'

This piece was a wedding gift, combining elements of the English countryside, plants and birds.

English Country Ducks by Anne Kelly.

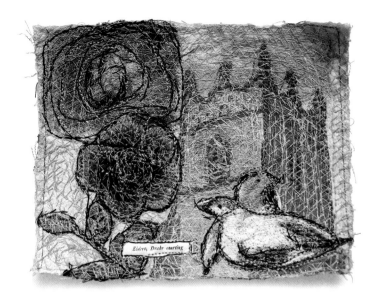

Marshlands – New to Old

After my first collaboration with the RSPB, *Sparrow Stories*, which was installed at The Hive education centre on Hampstead Heath, I was invited to exhibit at the RSPB Rainham Marshes nature reserve in Essex, in southern England. I drew on the link between the marshland at Rainham and the marshland habitat in Canada, in New Brunswick, where I trained as an artist. I made four panels called *Marshlands – New to Old*, which were displayed at the Purfleet Hide. I used a simple background to mount drawings of marshland birds from both countries, plants and plant outlines. The bottom edge of each piece was embroidered with plant stems and extended upwards into the main body of the work. I also included some large insect motifs. The whole piece was overstitched with large machined running stitch, in a wave-like pattern. I added a bright green vintage fabric border as a contrast to the dark outlines of the work.

Marshlands – New to Old by Anne Kelly, in situ at RSPB Rainham Marshes, Essex.

Sketchbook work on site

The power of the sketchbook as resource cannot be underestimated. Use it for experimentation, for getting down ideas, expressing feelings, collecting references, mark making and whatever else inspires you. Above all, use it when working outside or when researching at museums or attending workshops.

I like to sketch in my Shed Studio, where I have set up a nature table (see page 10) that I can use as reference in my own work or when teaching. The studio is in the middle of the garden and reflects the green spaces outside through its many windows. The proximity of the plants, birds and outdoor space make it a peaceful and contemplative place to work. It has also been a feature of our local open-studio organisation, South East Open Studies, for over ten years, and has hosted a number of guest artists as well as a core group of artists connected through thematic approaches.

Student sketchbook, Shed Studio, coloured pencil on paper.

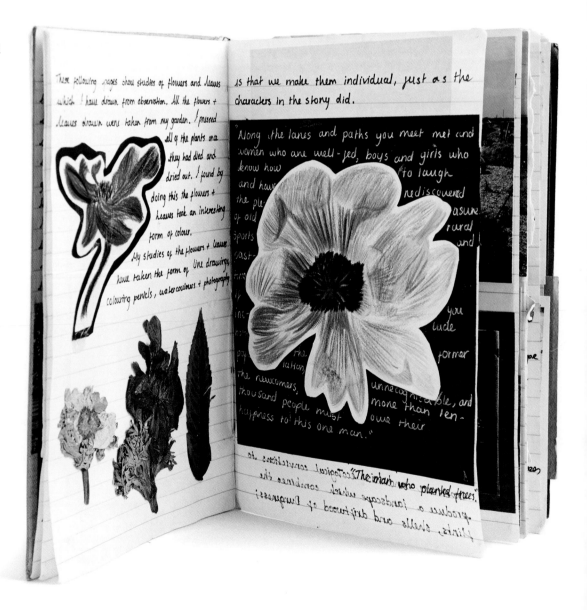

Karl Simmons

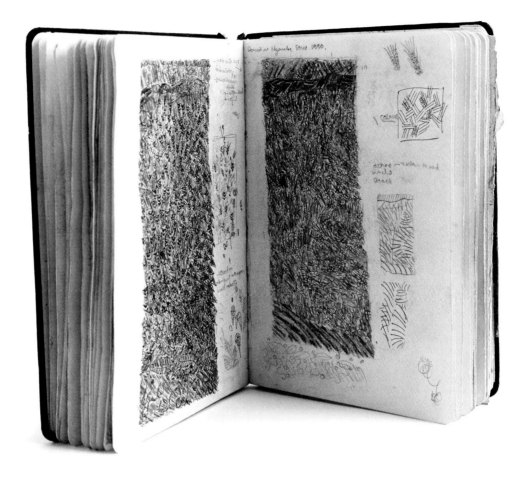

Karl is a painter based in London. On his travels around the UK and abroad he keeps detailed sketchbooks, which he uses to paint from. They contain fascinating records of his thought processes and the drawings he uses as source material for his work. They have a magical and light touch, which imbue his larger paintings and are works of art in themselves. They have been used as teaching tools for his students.

Sketchbook pages, mixed media on paper by Karl Simmons.

Jennifer Collier

Jennifer explains her work as re-making household objects from stitched recycled papers. She says: '*My practice focuses on creating work from paper; by bonding, waxing, trapping and stitching I produce unusual paper "fabrics", which are used to explore the "remaking" of household objects. The papers are treated as if cloth, with the main technique employed being stitch; a contemporary twist on traditional textiles. The papers themselves serve as both the inspiration and the media for my work, with the narrative of the books and papers suggesting the forms. I tend to find items then investigate a way in which they can be reused and transformed; giving new life to things that would otherwise go unloved or be thrown away.*'

I have chosen to highlight Jennifer's birdhouses, which show the delicate selection of imagery that she uses in her work. Jennifer has led the way in the upcycling revolution in art and craft; a veteran maker of vintage material, investigating the themes of reuse and recycling. Every exquisite detail is made, folded and manipulated from paper. Once books, maps, envelopes, wallpaper or scrap, the paper is transformed into textural forms. Like cloth it is stitched to construct two- or three-dimensional objects, decorative and functional: lampshades, cameras, tools and furniture. The origin of the paper often provides a starting point for the artwork: the narrative of the books and papers suggesting idea and form. Jennifer's work centres around domestic objects made entirely from paper: upholstered chairs, kitchen utensils and garden tools hanging in their shed invite you in. References to fairytales, films, literature, music and nursery rhymes – the layers of paper and meaning together build the narrative.

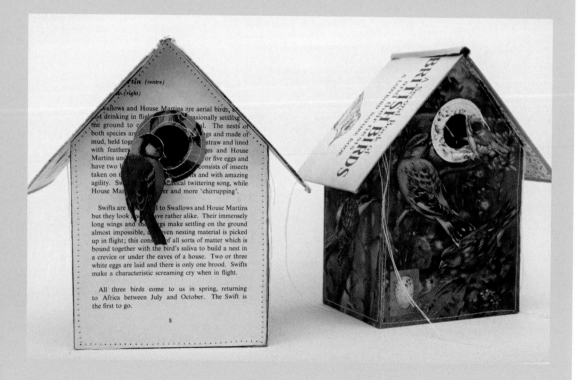

Birdhouses, mixed-media textile construction by Jennifer Collier.

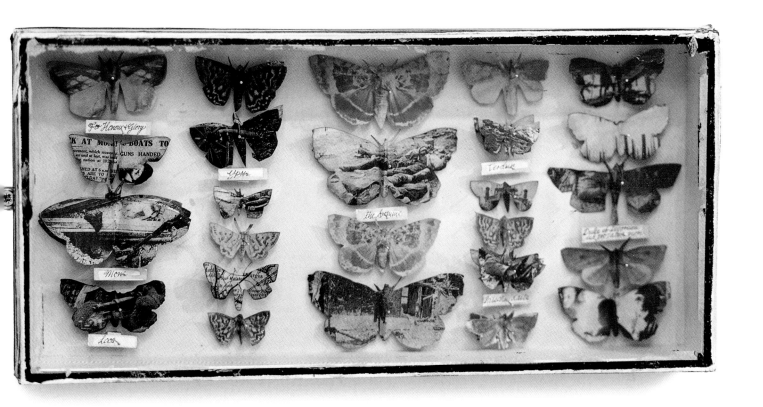

Jane Churchill

Jane is a Sussex-based artist who trained as a set designer and her work encompasses the theatrical but is also heavily influenced by natural history, memory and more recently the personal histories of the First World War. Jane says: *'This box is part of my immersive installation* Degrees of Separation, *which tells glimpses of Will and Jessie's love story, of loss and connection through the First World War. My mixed-media work explores the boundaries between truth and fiction, created artwork and artefact.*

In July 1917 Lieut. W.G. Hicks was killed near Arras in France. He left behind his fiancée Jessie Ellman. This museum box of moths, which was inspired by Victorian natural history collections, is part of a larger piece based on Jessie's feelings about the extent of the casualties in the First World War, each moth representing a fallen soldier.'

Jessie Ellman's Collection of Years 1916, hand-cut moths made from vintage paper in museum box by Jane Churchill.

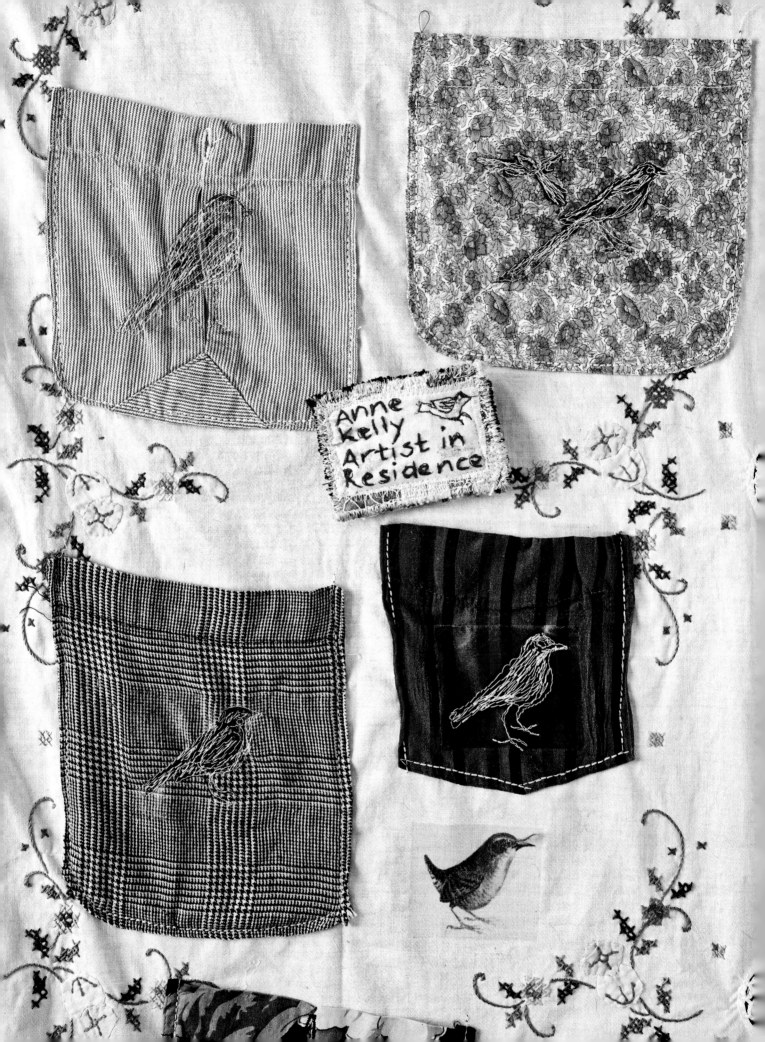

Anne
Kelly
Artist in
Residence

Nature in context

'Tell your own story, and
you will be interesting.'
Louise Bourgeois

Images of nature can be used at face value for purely aesthetic reasons, but some artists like to dig deeper and load their art with symbolic meanings and resonances. In this chapter, I will look at the work of artists who use nature and natural imagery as a conduit for making a personal statement about issues that concern them. I will also look at the Goldsmiths College collection of textiles, which is a useful resource for study and research. The chapter will conclude with some examples of textiles influenced by nature from different parts of the world.

Hanging by Anne Kelly
from Covered Wagon studio,
Sussex Prairie Garden.

I who will slip from this earthly place
Have been struck down
 by a cruel embrace
I cannot speak, hear nor see
And rue the day I married thee

(OVER) WROUGHT BY JOAN DYER

Caren Garfen

The intricately and beautifully stitched work of Caren Garfen belies a much more serious and arguably more subversive purpose. I was drawn to her sampler *There Are No Words...* with her use of animals and plants. Caren says: 'When I create an artwork I endeavour to understand the nature of gender inequality by examining women's societal roles in the 21st century, although my most recent works have been site responsive. These have necessitated looking into the past to reveal interesting facts about women's lives in both the 1800s and, in the case of the sampler, There Are No Words to Embroider That Single Desolating Fact, the 1500s. My work can be seen as a feminist campaign; the making becomes a spirited action which pursues a political or social end. My meticulous and time-consuming hand-stitched words are chosen to raise people's awareness of issues concerning females today. These art pieces are contemporary banners documenting women's lives in the present and from the past. Textiles are of particular importance in enabling me to put my ideas across. Textiles are something that everyone can relate to – they are part of our everyday lives.

All of my work commences with a flat sheet of fabric which is eventually manipulated into a finished artwork, taking the form of everyday domestic objects such as bedding, tea towels or a kitchen-paper towel roll. The viewer can recognise these immediately, but on closer examination they will find that there is more to them than meets the eye. In creating There Are No Words... it was important to re-create something that resonated with the National Trust property Newark Park in Gloucestershire. I wanted to embellish the piece with symbolism and coded messages and felt the best way forward was to painstakingly hand stitch a sampler. The building was originally a hunting lodge so it was essential to add motifs to emphasise this. Thus deer, foxes, birds and trees were sewn into this work. I use humour too by combining handmade and hand-stitched labels with either silkscreen printed or stitched imagery. I am interested in how a play on words can be extracted from a sentence, which is thereby transformed to reveal a greater truth. Although we have made a good deal of progress since women first got the vote, it seems to me that we still have a long way to go, in terms of our working lives, childcare and self-image, and I will continue to highlight all of these issues, and others, in future artworks.'

There Are No Words..., hand-stitched textile by Caren Garfen.

Independent Minded Women

In this embroidery mounted onto canvas, I am expressing some thoughts about my family history by recycling a piece made by my grandmother. She was a great needlewoman, and made work in all media: lacemaking, embroidery, quilting, knitting, crocheting and rug-hooking. I chose to use the embroidery of thistles to create almost a 'family tree' with mentions of four generations embroidered over the top. I was happy to include other fragments of embroidery, print and some fabric brought back from Africa by my daughter Ruth. Both of my formidable grandmothers get a mention. It is a piece that, although explicit with its wording, hopefully also makes you think again.

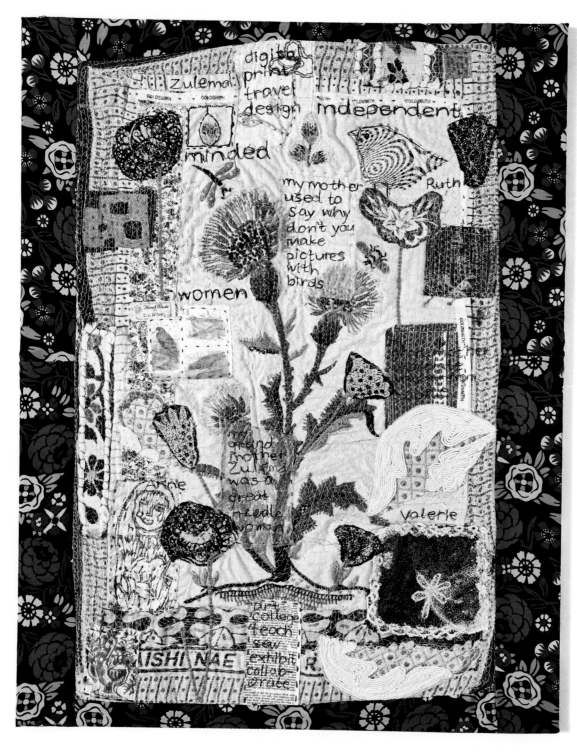

Independent Minded Women, mixed-media textile on canvas by Anne Kelly.

Lynn Setterington

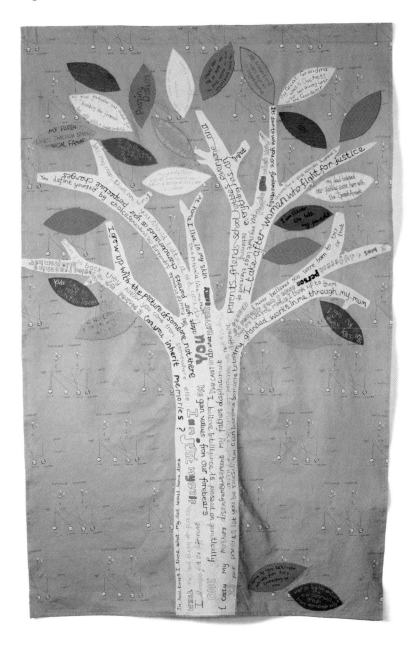

Passing Down,
mixed-media textile
by Lynn Setterington.

Lynn is an internationally recognised artist working in the textiles arena. Celebrations of the ordinary and overlooked are key themes in Lynn's work. She became known for her use of kantha embroidery in the early 1990s and has since gone on to devise and instigate a large number of social engagement projects and textile collaborations with diverse groups. Lynn says: '*Passing Down was a collaborative project with poet Helen Clare to create a large-scale embroidered poem as part of the Manchester Science Festival 2008. The final poem is configured as a tree of life/family tree made up of series of quotes and statements from the participating groups. Individual leaves were stitched by students from the Embroidery Programme at Manchester Metropolitan University to add different voices to the narrative. The cloth is on display at Nowgen, a genetics research centre in Grafton Sreet, Manchester, next to Manchester Royal Infirmary.*'

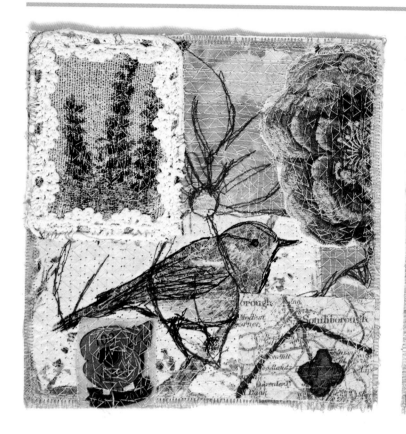
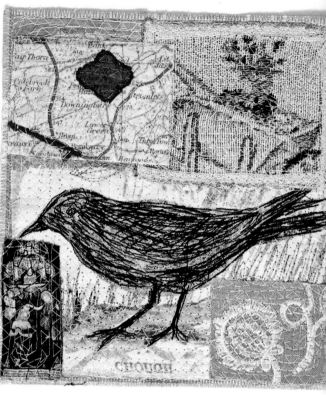

Amelia Scott

I was invited to put together an exhibition for the corridor galleries at our local Tunbridge Wells Hospital in Kent. I wanted to reflect some of the history of the hospital and its role in our town, although it is a relatively new building. Amelia Scott was an eminent philanthropist and supporter of women's suffrage and was vice president of the Tunbridge Wells branch of the National Union of Women's Suffrage Societies. I was able to view some of Amelia's original letters and documents at The Women's Library Reading Room, which is now housed in the LSE Library.

Amelia was active in all aspects of women's work in Tunbridge Wells during the First World War, including the establishment of the Soldiers' Central Laundry. She was awarded the Gold Palm Order of the Crown, an extremely prestigious award, in 1929, by the King of the Belgians, for her work with Belgian refugees. I wanted to reflect the surroundings of the hospital, which Amelia helped to support on this site, by using birds from the area. There are also plants and maps from the town, marking the areas where Amelia and her sister lived and worked. There are small references to her work in the First World War – poppies, nurse's uniform and her leaflet bag.

Amelia Scott's Birds, mixed-media textile by Anne Kelly.

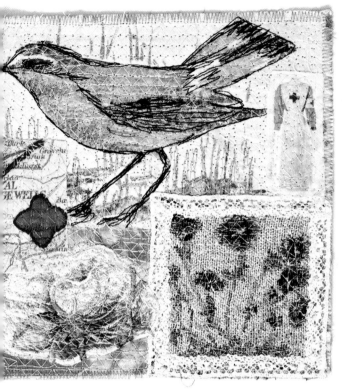

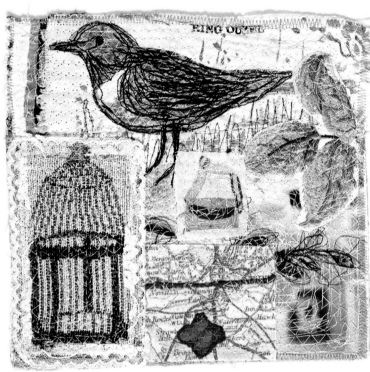

Amelia Scott's Birds
in situ at Tunbridge
Wells Hospital.

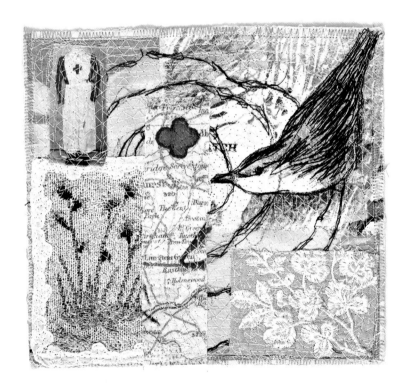

Goldsmiths Textile Collection and Constance Howard Gallery

The Goldsmiths Textile Collection and the Constance Howard Gallery are located at Deptford Town Hall, part of Goldsmiths, University of London.

The textile collection illustrates the history of textiles at Goldsmiths from the 1940s to the present day and includes works by alumni of Goldsmiths and other textile artists, as well as ethnographic and historical textiles and dress.

The collection is used by a wide variety of researchers from different disciplines including visual arts, anthropology, history and design. Students, academic staff and researchers, both from within Goldsmiths and outside, together with members of the public use the collections.

There is a reference library which, in addition to books, holds journals and an extensive collection of pamphlets and exhibition catalogues. The Constance Howard Gallery holds exhibitions of textiles. These include pieces from the collection or from associated research projects, or work by textile artists, students or alumni.

Purse made from apple seeds, held at Goldsmiths Textile Collection, Library, Goldsmiths, University of London.

Small straw woven sewing case from Africa, held at Goldsmiths.

Purse decorated with peacock feathers, held at Goldsmiths.

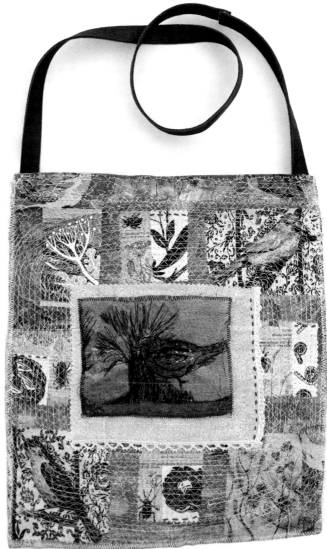

Moth Bag, mixed-media embroidered textile on bag form by Anne Kelly.

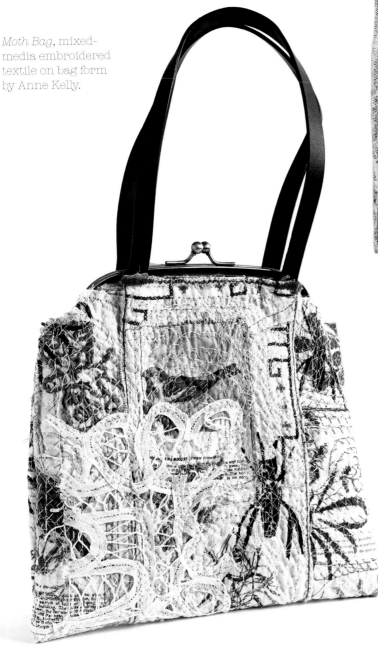

Primitive Bag, mixed-media embroidered textile pieces appliquéd on bag form by Anne Kelly.

Nature bags

Inspired by the collection at the Constance Howard Gallery, I made some bags using natural themes. I upcycled readymade bags and stitched embroidered panels onto the existing shapes. I aimed to match the images with the shape of the bags, so that they enhanced the style and form of the bags.

Travel in textiles

Russia

Other sources of inspiration can be taken from the interpretation of nature. In October 2013, I visited Moscow and the wonderful All Russian Museum there. It has a large collection of folk art – from wooden painted sleds to the embroidered panels, which particularly interested me. These reinforced my love of traditional pattern, embodied in folk and naïve art. The predominant colour of these samples was red, which I had been exploring through my own work at that point. The patterns included elements of the natural world, which is another recurring theme in my work. I made some initial sketches using pencils and a fine line pen, taking note of the colours involved. I then added some watercolour to the drawings the same day, back at my hotel. I wanted to use a limited palette to reinforce the colour schemes that I associated with this style of folk art and to capture the mood and feeling of the museum, through sketching.

When I had finished my preliminary sketches, I started to plan a series of work based on my visit and the embroidery that I had seen at the museum. I like to use fabric that relates to the place that I am working on and has a connection to it. I chose to use as a base fabric and background an old evening dress from Eastern Europe with a satin finish. I had decided to work on a triptych and to create a top and middle section and shoe section from the imagery and newer textiles that I had collected on my visit.

I began by covering the base with a sheer nylon curtain fabric, with a slight pinky tinge. This immediately neutralised the background without completely covering the outline of the dress. It also provided a 'blank canvas' to work on.

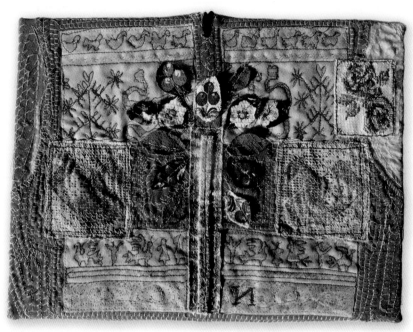

Russian Folk, mixed media textile by Anne Kelly.

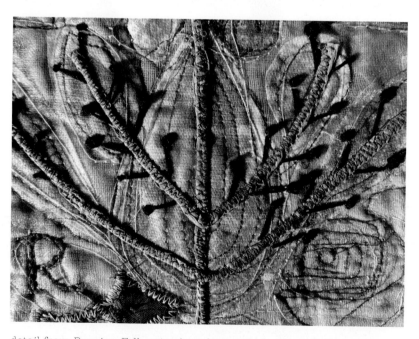

detail from *Russian Folk*, mixed media textile by Anne Kelly.

Once I was back in the studio, I then turned my attention to the patterns themselves, and made some transfers of sections of my manipulated photographs onto printable canvas. These sections were incorporated into the background and made into separate motifs, like the butterfly and flowers as part of the tops. As the transfers themselves were quite pale, I decided to make the pattern more prominent by stitching over it, using a free machine embroidery foot. This made me appreciate quite how intricate and involved the patterns must have been to weave, print and stitch.

Prague

I was invited to exhibit at the Prague Patchwork Meeting and to teach a workshop there. I drew on the theme of 'windows' and using a mixture of vintage and new fabric, produced a demonstration piece for the group. I was trying to capture the feeling of the old city with its distinctive architecture.

Starting with a handkerchief as a background, we added drawings and collaged elements of views from the city. These were stitched onto the base and then overstitched with free-motion embroidery and some hand stitching.

Canada

A small piece in the form of a postcard, where images from both the UK and Canada link the two locations, along with remnants of cross stitch.

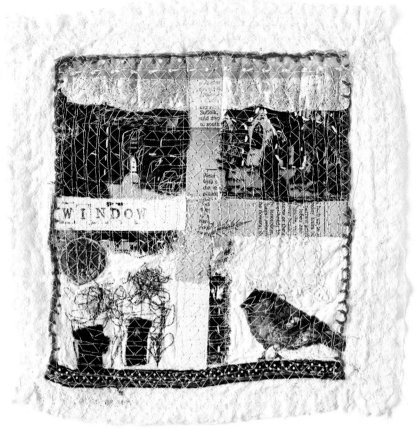

Prague Window, mixed-media textile on vintage fabric by Anne Kelly.

Canada Card by Anne Kelly.

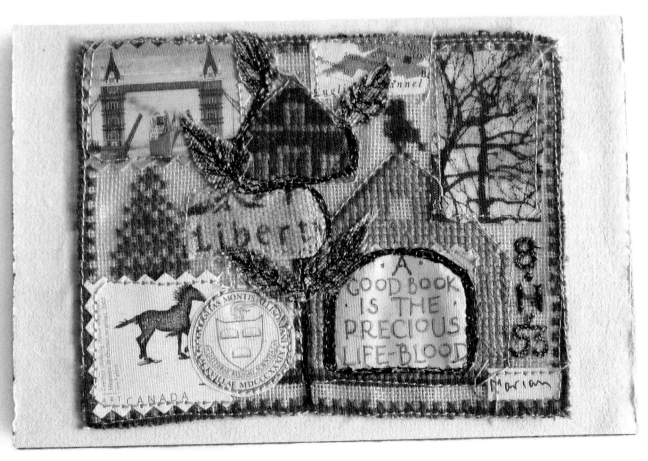

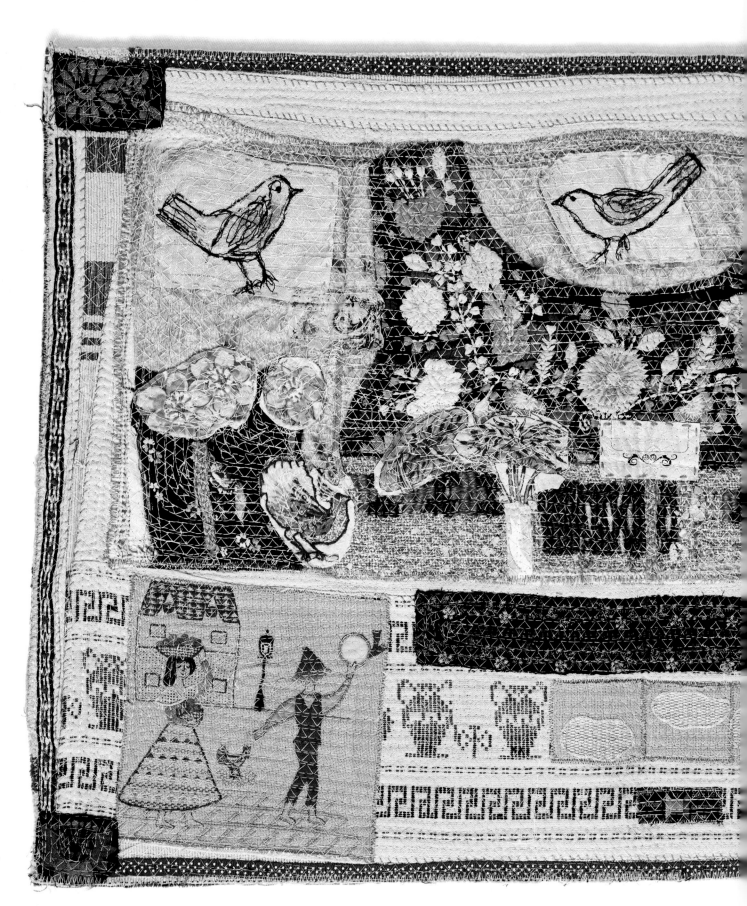

Greek Dress Apron, mixed-media textile by Anne Kelly.

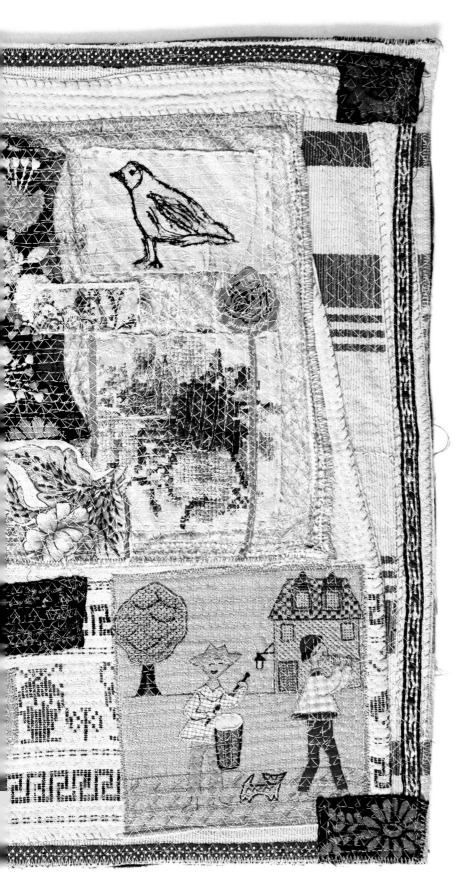

Aprons series by Anne Kelly in the Corridor Gallery, World of Threads Festival, Oakville, Canada.

Aprons series

My *Aprons* series was designed as an autobiographical series of work, describing different environments that I have been a part of, and each one referencing travel and the natural world. Earlier pieces from the series were exhibited at my solo exhibition at the Trinity Town and Country Gallery in Tunbridge Wells, Kent. Carolyn Forster, author and quilter, wrote: '*The materials were everyday and accessible and also evocative; it inspired me to want to get stitching … even though you could create your own work you still wondered if it had as much to say or as much depth as Anne's work*'. Five pieces of work from the series were exhibited at the International World of Threads Festival in Canada.

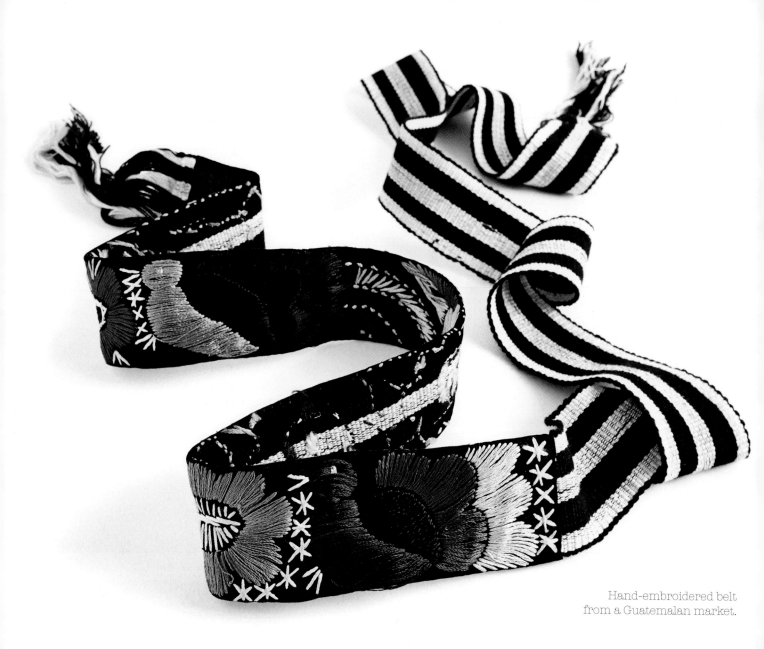

Hand-embroidered belt
from a Guatemalan market.

North and South America

In November 2014, I was able to visit an amazing collection of First People's work from Canada at the McCord Museum in Montreal. It was a poignant experience as I grew up in the city and remember visiting the museum as a small child. The museum describes the collection: *'The exhibition is a must to discover ancient traditions where the creation of original garments proved a rich heritage of identities and cultures. Because dress is not only utilitarian, it is used to quickly distinguish allies from enemies, indicate the power of spiritual leaders such as shamans, or, by wearing finely decorated clothing, show a hunter's respect towards animals on which his family depends for survival... Dress participates in the development, preservation and communication of social, cultural, political and spiritual identities of First Nations, Inuit and Métis.*

The hand-embroidered belt (above) from Guatemala was made by a local craft cooperative. It features flower and bird motifs, heavily embroidered in satin stitch on a woven cotton belt.

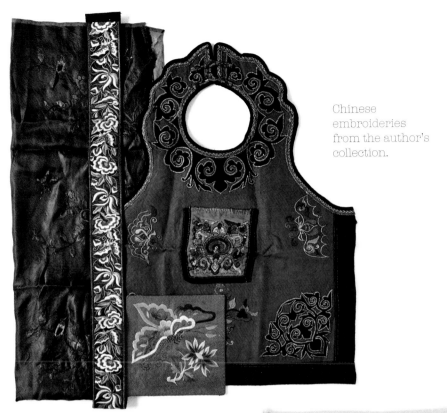

Chinese embroideries from the author's collection.

China

I was fortunate enough to be able to visit China twice in the last few years, and naturally was keen to see a collection of textiles while there. I went to the Chinese Museum of Women and Children in Beijing, where I saw an amazing collection of textiles from the 53 ethnic regions of China. I also found some samples at the antique market in Beijing from old pillow-end covers. The embroidery is intricate, colourful and very inspirational. The colours, although faded, remain rich and sensual.

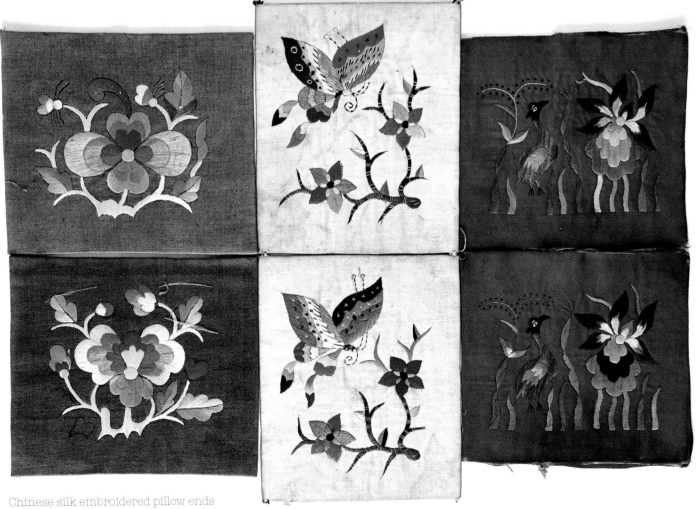

Chinese silk embroidered pillow ends from the author's collection.

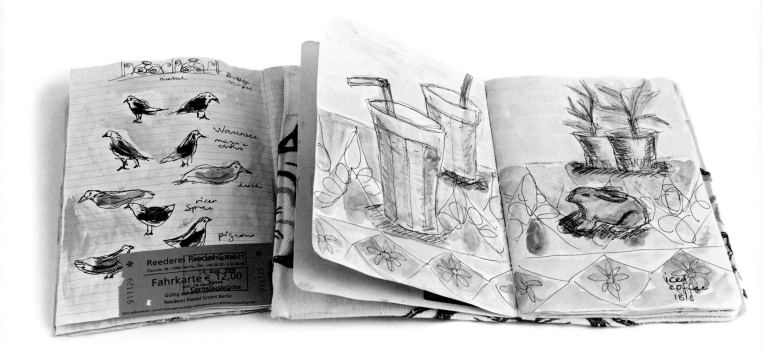

Travel sketchbooks and studio

Whenever I travel, I take small sketchbooks with me and make notes and drawings. These are invaluable when back in the studio and often become pieces in their own right. On a recent visit to America I used some folk-art inspired fabric from a thrift shop there and used a room in the flat where I was staying as an impromptu studio. I have worked in hotel rooms, on aeroplanes, wherever I am.

Travel sketchbooks by
Anne Kelly.

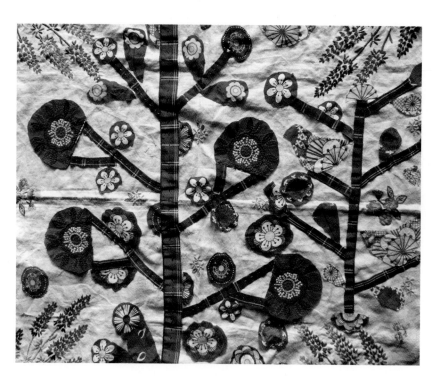

Red Tree, work
in progress by
Anne Kelly.

Needlecase

I like to make practical items as well as creating pieces for framing or hanging. A needlecase is a particularly useful item for textile artists and it offers an opportunity to sample a new technique or display a small finished piece. I don't like to get too hung up on the dimensions – I just work with what I've got – but there is plenty of free instructional information on the Internet if you like to work to a prescription. My method is laid out below:

1 Choose a remnant of strong fabric and/or vintage fabric for the cover of the case.

2 Add an appliquéd image to the cover at this stage if you wish – I've chosen a bird. Work stitching over the fabric as desired and add any other adornments.

3 Use felt pieces for the inside, to hold the needles. Make the felt pieces slightly smaller than the cover.

4 Pin the felt pieces into place and sew along the spine of the case to join the pieces together.

Needlecase by Anne Kelly.

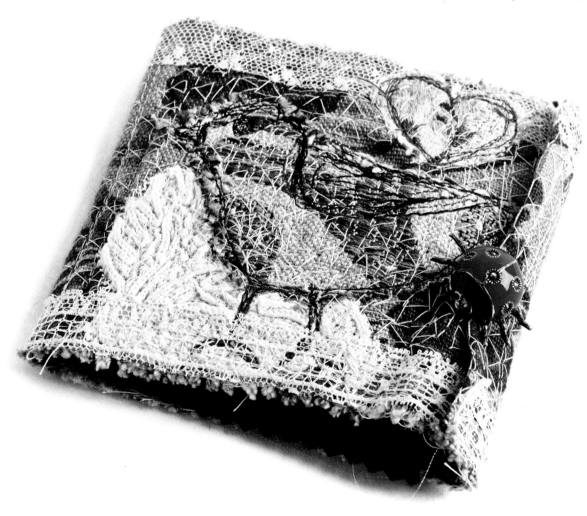

Conclusion

'The art of writing is the art of discovering what you believe.'
Gustave Flaubert

When I started working on this book three years ago, I soon realised what a huge area of study the bond between textiles and nature could be. I have tried to select areas that will interest and encourage artists, students and educators of textile art. By providing some contextual links and resources, I hope that readers will be inspired to take the topic further.

Textile Nature started with some simple connections between seeing and making, taking influences from the natural world. My aim has been to illuminate our attachment to nature and to see how we can use this to reflect our surroundings and location in the wider community. By exploring different aspects of making; through drawing, stitch, print, construction and weave, the book presents ideas and starting points.

I am very grateful to all the artists, individuals and institutions that have generously allowed the reproduction of their images and words. The book is much richer as a result. I have also been fortunate to work with some wonderful tutors and teachers who have linked their practice with the natural world, and helped me to locate my niche in it.

It is no coincidence that this book starts and ends with quotes by two French writer/ philosophers. My husband trained as a philosopher and has been my strongest supporter. I would also like to thank my children and their partners and this book is dedicated to all of them.

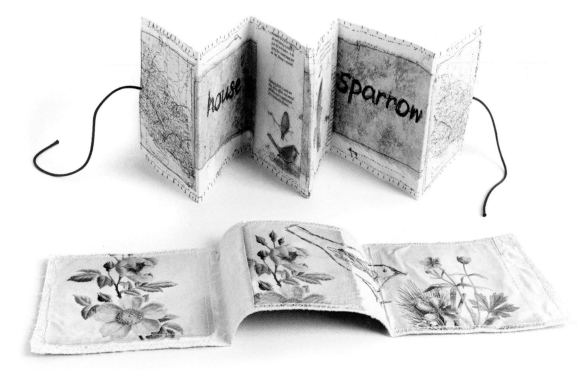

House Sparrow folding books by Anne Kelly.

Mixed-media collages by Anne Kelly.

SELECTIONS FRO...

TO FANCY

EVER let the Fancy roam,

...he

...gh the mist and...

...ng: What do th...

...ingle, whe...

...blazes bri...

...inter's nig...

B... A...

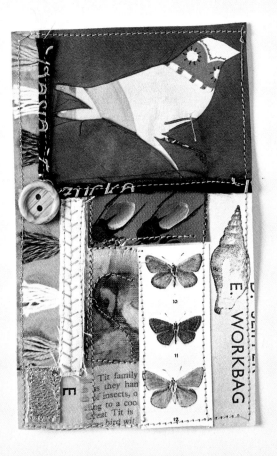

E. WORKBAG

BUTTONS

HIRUNDINIDAE. Swallows

The Swal...
of our b...
and loved...
visitors,
favoured...
poets. It...
distinguis...
the other...
of the...
the blue...
the back...
and the l...
tail. Th...
dull ches...
dark blue...
low it.

...well-kn... bedding plant now used far more than was
...nce the o...nd often replaces lobelia. It is an annual but
...being half...y, seed must be raised in a warm house to
...rovide y... plants for planting out in May. Once the
...eedlings ...ricked out they develop quickly and therefore

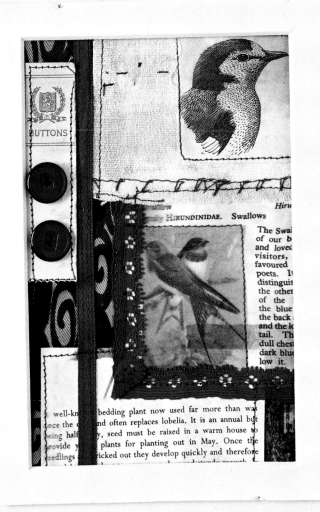

Featured artists

My links:

www.annekellytextiles.com
www.annekellytextiles.blogspot.co.uk
www.annekellytextiles.wordpress.com
www.craftscouncil.org.uk/directory/maker/anne-kelly-textiles

Artist websites

Melanie Bowles
www.melaniebowles.co.uk

Jane Churchill
www.janechurchillartist.com

Jennifer Collier
www.jennifercollier.co.uk

Anna Dickerson
www.annadickerson.com

Melvyn Evans
www.melvynevans.com

Hillary Fayle
www.hillaryfayle.wordpress.com

Carolyn Forster
www.carolynforster.co.uk

Alice Fox
www.alicefox.co.uk

Catherine Frere-Smith
www.catherinefreresmith.com

Caren Garfen
www.carengarfen.com

Cas Holmes
www.casholmestextiles.co.uk

Val Holmes
www.textile-art-centre.com.fr/
val-holmes

Nicola Jarvis
www.nicolajarvisstudio.com

Small Flower, mixed media embroidery by Anne Kelly.

Rosie MacCurrach
www.rosiemaccurrach.com

Gaby Mett
www.gabi-mett.de

Ellen Montelius
www.ellenmontelius.com

Alison Milner
www.alisonmilner.co.uk

Judith Mundwiler
www.judithmundwiler.ch

Carol Naylor
www.carolnaylor.co.uk

Jane Nicholas
www.janenicholas.com

Nancy Nicholson
www.nancynicholson.co.uk

Emily Notman
www.emilynotman.co.uk

Emma Nishimura
www.emmanishimura.com

Lesley Patterson-Marx
www.lesleypattersonmarx.com

Louise Pettifer
www.louisepettifer.co.uk

Leisa Rich
www.monaleisa.com

Lynn Setterington
www.lynnsetterington.co.uk

Suzette Smart
www.suzettesmart.wordpress.com

Maxine Sutton
www.maxinesutton.com

Karen Suzuki
www.namelesswonders.jimdo.com

Lindsay Taylor
www.lindsay-taylor.co.uk

Kim Thittichai
www.kimthittichai.com

Pauline Verrinder
www.paulineverrinder.com

Jane Will
www.flowersanddaughters.co.uk

Meredith Woolnough
www.meredithwoolnough.com

Further information

All-Russian Decorative,
Applied and Folk Art Museum, Moscow
www.russianmuseums.info/M276

The Beaney House of Art and Knowledge, Canterbury, UK
www.canterbury.co.uk/beaney/

Booth Museum, Brighton, UK
www.brightonmuseums.org.uk/booth

Chelsea Fringe
www.chelseafringe.com

The Chinese Museum of Women and Children, Beijing
www.ccwm.china.com.cn

Ditchling Museum, East Sussex, UK
www.ditchlingmuseumartcraft.org.uk

Embroiderers' Guild
www.embroiderersguild.com

The Fibreworks, Oxfordshire
www.thefibreworks.co.uk

Goldsmiths Textile Collection
www.gold.ac.uk/textile-collection

Great Dixter House and Gardens, East Sussex, UK
www.greatdixter.co.uk

The Harbour Gallery, Jersey
www.theharbourgalleryjersey.com

The Hospice in the Weald, Kent, UK
www.hospiceintheweald.org.uk

The Knitting and Stitching Show
www.theknittingandstitchingshow.com

McCord Museum, Montreal, Canada
www.mccord-museum.qc.ca

Mississippi Valley Textile Museum, Canada
www.mvtm.ca/mvtm

Narodni Museum, Prague, Czechoslovakia
www.nm.cz

Prague Patchwork Meeting
www.praguepatchworkmeeting.com

The Quilters' Guild
www.quiltersguild.org.uk

Royal School of Needlework
www.royal-needlwork.org.uk

Royal Society for the Protection of Birds (UK)
www.rspb.org.uk

Sissinghurst Castle Garden, Kent, UK
www.nationaltrust.org.uk/sissinghurst-castle-garden

Sussex Prairies Garden, West Sussex, UK
www.sussexprairies.co.uk

World of Threads Festival, Canada
www.worldofthreadsfestival.com

The Women's Library Reading Room, at the London School of Economics Library, London
www.lse.ac.uk/library/collections

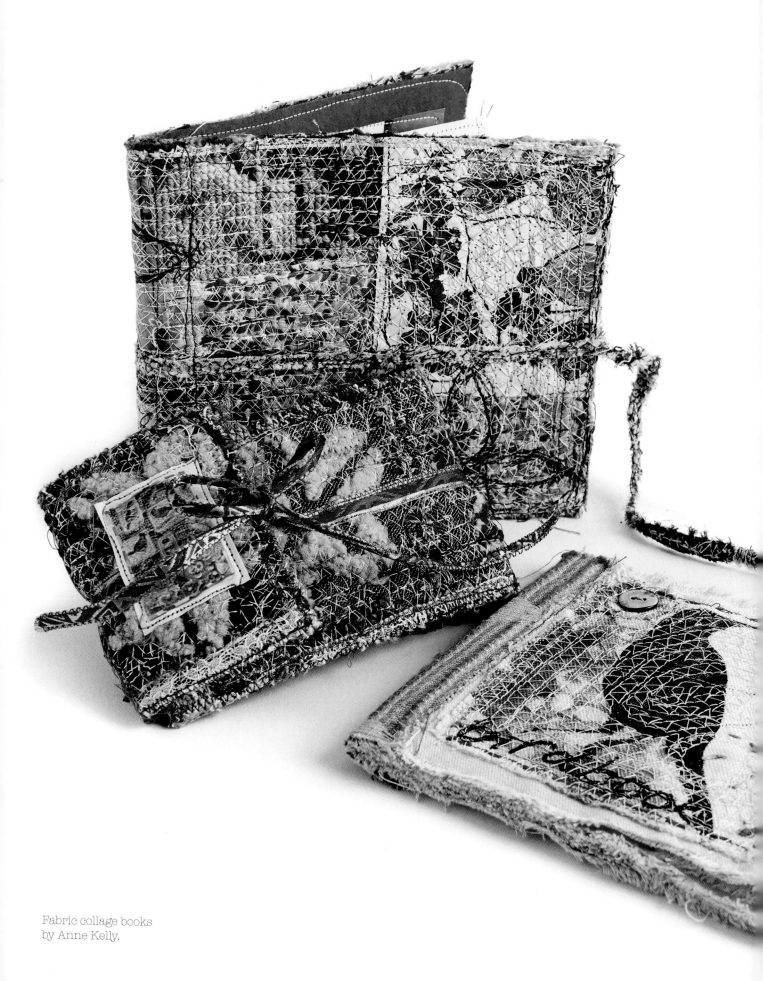

Fabric collage books
by Anne Kelly.

Further reading

Bourgeois, Louise, *Stitches in Time* (August Projects/MOCA, 2003)

Bowles, Melanie, *Digital Textile Design* (Lawrence King, 2012)

Brodie, Antonia, *V&A Pattern: Garden Florals* (V&A Publishing, 2010)

Cleeves, Tim and Holden, Peter, *RSPB Handbook of British Birds* (Bloomsbury Natural History, 2014)

Flint, India, *Eco Colour: Botanical dyes for beautiful textiles* (Murdoch, 2008)

Haxell, Kate, *The Stich Bible* (David & Charles, 2012)

Holmes, Cas and Kelly, Anne, *Connected Cloth* (Batsford, 2013)

Howard, Constance, *The Constance Howard Book of Stitches* (Batsford, 1979)

Scott, Rebecca, *Samplers* (Shire, 2009)

Tellier-Loumagne, Francoise, *The Art of Embroidery* (Thames & Hudson, 2006)

Suppliers

UK

George Weil
Old Portsmouth Road, Peasmarsh,
Guildford, Surrey GU3 1LZ
01483 565800
www.georgeweil.com

Seawhite
Avalon Court, Star Road Trading
Estate, Partridge Green, Horsham,
West Sussex RH13 8RY
01403 711633
www.seawhite.co.uk

Colourcraft (C&A) Ltd
Unit 6, Carlisle Court
555 Carlisle Street East
Sheffield S4 8DT
0114 242 1431
www.colourcraftltd.com

Art Van Go
The Studios, 1 Stevenage Road
Knebworth
Herts, SG3 6AN
01483 814946
www.artvango.co.uk

Bernina UK
91 Goswell Road
London EC1V 7EX
020 7549 7849
info@bernina.co.uk

Canada and USA

Textile Museum of Canada Shop
55 Centre Avenue
Toronto, ON
Canada M5G 2H5
(416) 599-5321
www.textilemuseum.ca/shop/tmc-shop

PRO Chemical and Dye
126 Shove St, Fall River
MA 02724
1-800-228-9393
http://www.prochemicalanddye.com

Australia

The Thread Studio
6 Smith Street
Perth, Western Australia 6000
(61) 8 9227 1561
www.thethreadstudio.com

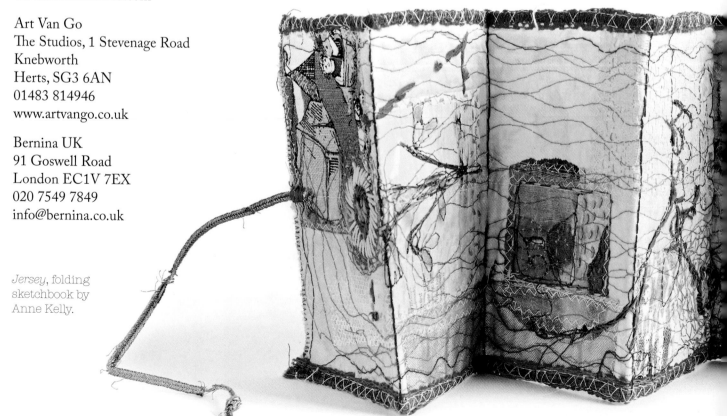

Jersey, folding
sketchbook by
Anne Kelly.

Picture credits

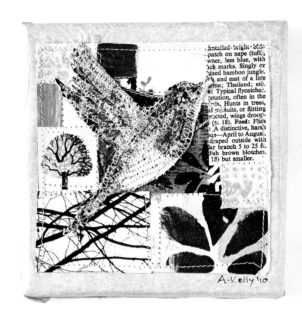

Photography by Rachel Whiting, with the exception of the following:

Melanie Bowles page 42 (top), page 42 (bottom); Jane Churchill page 101; Jennifer Collier page 100; Melvyn Evans page 21; Hillary Fayle page 31; Carolyn Forster page 51; Catherine Frere-Smith page 72, page 73; Caren Garfen page 105; Cas Holmes page 20 (top); Val Holmes page 38, page 39; Nicola Jarvis page 69; Anne Kelly page 6, page 8, page 10, page 11, page 14, page 16, page 18, page 19, page 33, page 46, page 48 (top), page 52, page 53, page 54, page 55 (top), page 58 (bottom), page 62 (centre), page 65; page 67; page 68 (top), page 70, page 77 (bottom), page 82, page 83 (top), page 84, page 85, page 92, page 97, page 112, page 114; Gabi Mett page 61; Alison Milner page 43; Judith Mundwiler page 56; Carol Naylor page 20 (bottom); Jane Nicholas page 63; Nancy Nicholson page 45; Emma Nishimura page 13; Emily Notman page 41; Lesley Patterson-Marx page 81; Louise Pettifer page 37 (top), page 37 (bottom), page 94; D. Ramkalswon page 110; Royal School of Needlework page 96; Suzette Smart page 71; Maxine Sutton page 44; Karen Suzuki page 74; Lindsay Taylor page 83 (bottom); Kim Thittichai page 25; M. West page 80; Michael Wicks page 30; Meredith Woolnough page 15.

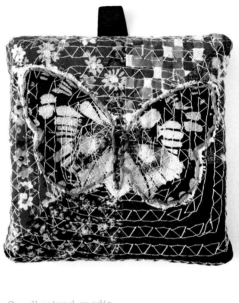

Small mixed-media canvasses by Anne Kelly.

Index